WATFORD

THROUGH TIME

John Cooper

AMBERLEY PUBLISHING

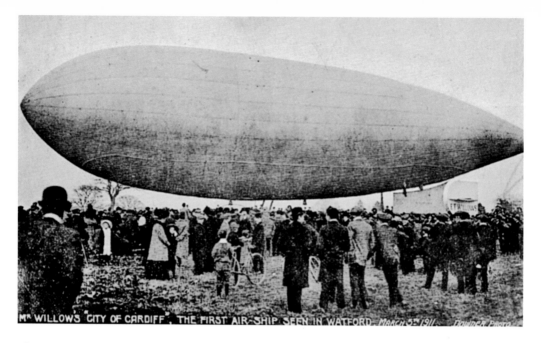

The *City of Cardiff* at Watford
During a blustery week in early March 1911, the *City of Cardiff* airship, piloted by the pioneer Welsh aviator and airship builder Mr E. T. Willows, was reported to have been a great centre of attraction on its arrival in Watford, where it was housed in a temporary hangar on a field just off Bushey Hall Road. Shortly after 5.00 p.m. on Sunday, 5 March, the enthralled crowd of spectators were treated to the exciting spectacle of the airship taking off, when it proceeded to make a wide circle over the town for thirty minutes.

Also by John Cooper:

A Harpenden Childhood Remembered: Growing up in the 1940s & '50s
Making Ends Meet: A Working Life Remembered
A Postcard From Harpenden: A Nostalgic Glimpse of the Village Then and Now

First published 2011

Amberley Publishing
The Hill, Stroud
Gloucestershire, GL5 4EP

www.amberley-books.com

Copyright © John Cooper, 2011

The right of John Cooper to be identified as the Author of this work has been asserted in accordance with the Copyrights, Designs and Patents Act 1988.

ISBN 978 1 4456 0607 1

British Library Cataloguing in Publication Data.
A catalogue record for this book is available from the British Library.

Typeset in 9.5pt on 12pt Celeste.
Typesetting by Amberley Publishing.
Printed in the UK.

Introduction

During the early part of the twentieth century, countless images of Watford were captured on camera by a small but dedicated group of photographers, the numerous pictures taken providing an everlasting legacy of the town's development, recording for posterity not only copious street scenes and buildings – many of which are now listed and preserved – but also events as diverse as floods and visiting royalty. Without their enthusiasm and commitment in recording mostly everyday views and occurrences, much of Watford's pictorial history would have been lost forever.

One of the important by-products of all these images was the picture postcard, a popular and fast means of communication in Edwardian times, where a message sent to a loved one in the morning was very often guaranteed to be received the same day.

Using a selection of these old postcards, many of which have been stored in dusty attics untouched for generations, coupled with modern-day photographs, this nostalgic glimpse into the fascinating scenes of yesteryear takes the reader on a journey around Watford, from the 'Four Cross Roads' where the Town Hall underpass was subsequently constructed, through Cassio Hamlet and along Hempstead Road to the Grove, the seat of the Earls of Clarendon. We witness the cheering crowds on the visit of King Edward VII to Watford in 1909 and wander through areas of Nascot and North Watford to the old Junction Station. Many pictures were also taken of Cassiobury Park, literally the jewel in Watford's crown, where children used to fish in the River Gade or sail a toy yacht on the paddling pool.

Our leisurely stroll along the towpath of the Grand Union Canal brings us back once again into the beautiful parkland, originally part of the Earls of Essex estate, before we leave and cross the Rickmansworth Road towards the disused Watford West railway station in Tolpits Lane, where nature has reclaimed the land where once steam trains

travelled, the rusting tracks now overgrown with undergrowth and flora. We see the many changes that have occurred in the High Street and beyond, including the construction of the prestigious Harlequin Centre, and how the Parade and Pond area appeared in those halcyon days before the flyover was constructed.

We pause for a moment to admire the beautiful Church of St Mary the Virgin built in 1230 and the old Free School founded in 1704 by Elizabeth Fuller, and situated at the south-west corner of the churchyard before wandering through the old market area where the lowing of cattle once mingled with the shouts and buzz of conversation from the many traders. As we pass the pond where the nannies from the big houses once walked with their young charges, we reach our journey's end, a journey that has shown us a brief but memorable view of *Watford Through Time*.

Today, Watford is a vibrant, prosperous and multicultural town of over 80,000 people. Despite the many changes and modernisation that have taken place as part of continuing progress, the town can be justifiably proud of its history for the benefit of future generations.

John Cooper

Acknowledgements

I am indebted to the following for their assistance:

Richard Anderson, St Andrew's Church; Sue Brandon, Watford Central Library; Colin Bullimore; John Castle; Pat Denton, Watford Central Library; Pam Chipperton; Sarah Costello, Watford Central Library; Norma Fell; Tom Forryan, Pastor, Derby Road Baptist church; Lisa Freedman, Royal Caledonian Schools Trust; Katie George, Salters' Company Archivist; Ralph Gregory, British Waterways; Simon Guy, Building Research Establishment; Jackson Jewellers; Simon Jacobs, Editorial & Public Relations Photography; Don Lanstone, Watford Camera Club; Jean Machin; Dennis Maney, British Waterways; Kelly Metcalf, Watford Borough Council; Michael A. Morant; Network Rail; Sarah Priestley, Watford Museum; Jack & Jill Ray; Lionel & Wendy Trussell; Jill Waterson, North Watford History Group; Justin Webber, Watford Borough Council and Whippendell Marine Ltd.

I am grateful to Vanessa Lacey, Watford Central Library; Roger Middleton, Curator, Hertfordshire Fire Museum and Cynthia & John Morgan for their kind permission to use some of their photographs and/or material.

I am also grateful to Mary Forsyth, Watford Museum for her advice and for giving me the benefit of her extensive local history knowledge.

Special thanks are extended to my wife Betty for her constant support, encouragement and invaluable input, to my son Mark for his continuous IT support, and to my publishers for their kind assistance in producing this publication.

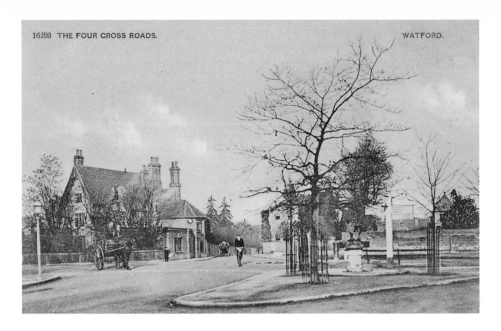

16203 THE FOUR CROSS ROADS. WATFORD.

The Cross Roads

The peaceful scene in this rural-looking postcard was captured in the early part of the twentieth century when the pace of life was considerably slower and more tranquil than it is today. Captioned 'The Four Cross Roads', this was the junction where St Albans, Hempstead and Rickmansworth Roads met with the High Street. The large dwelling to the left of St Albans Road, where the lone cyclist can be seen emerging, is Little Nascot, once the property of Messrs Humbert & Flint, Auctioneers and Surveyors, and later a maternity clinic. With the steady increase in the volume of traffic, a major reconstruction programme commenced in 1936 to transform the crossroads into a roundabout. Unlike now, vehicles could travel up and down the High Street, which then formed the main route to Bushey, Harrow and London. With traffic congestion becoming ever more acute in and around the town centre, work began in 1972 on building the new St Albans Road underpass, as seen below today, a far cry from that idyllic picture taken so long ago.

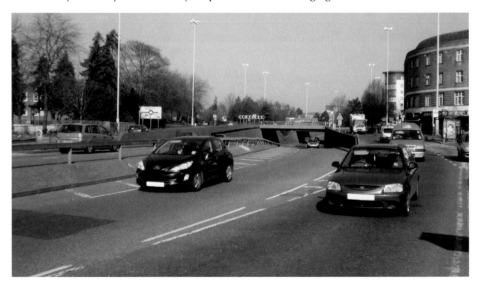

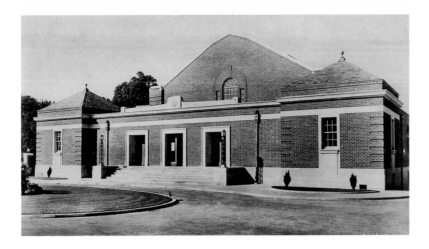

Watford Central Swimming Baths

Before the Central Baths, above, were opened in 1933, swimmers had to make do with somewhat unhygienic facilities compared with modern standards, at a pool in the shadow of the Five Arches railway viaduct. The arch through which the River Colne flowed was partitioned off, and the river on the other side extended to form a large square-shaped lido. Around this area were a number of wooden changing rooms with a gallery along the top to accommodate spectators. There were separate sessions for male and female swimmers as mixed bathing was not allowed. With the move to Hempstead Road, swimmers were not only able to enjoy undercover bathing all year round in what was believed to have been the world's first electrically heated pool, but also included amenities such as a spring board, high diving board and a water chute, although these were eventually removed as they were deemed to be a safety hazard. After more than seventy-three years of swimming at Watford Central, the baths eventually closed for major redevelopment in December 2006, reopening again twenty months later in August 2008 with a new up-to-the-minute pool under the changed name of Watford Leisure Centre, Central.

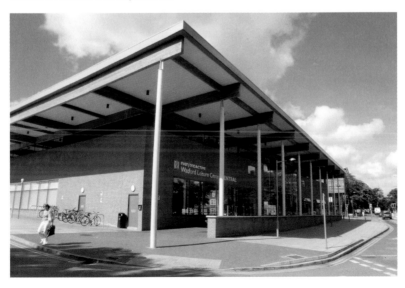

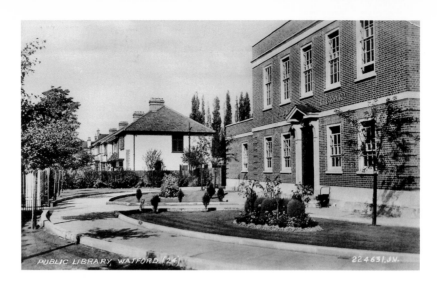

PUBLIC LIBRARY, WATFORD (24) 224631 JV.

Central Public Library

Originally sited in Queen's Road in the mid-1870s, the library relocated to its present position in Hempstead Road when the new Georgian-style building was opened in 1928 by Sir Fredrick G. Kenyon, Director and Principal Librarian of the British Museum, at a cost of £20,000, partly funded with a grant donated from the Carnegie United Kingdom Trust. The location, which at the turn of the century was known as Cassio Hamlet, was described as 'excellent' at the time due to its close proximity to the Junction railway station and the crossroads of Watford's four main thoroughfares. The houses to the left of the picture above were eventually demolished to make way for part of the new road system development, and to accommodate a car park. In addition to the many books on the open shelves, the local studies room boasts a comprehensive collection of directories, maps, photographs and local histories that provide a veritable treasure-trove of information to anyone interested in the fascinating yesteryear of our town.

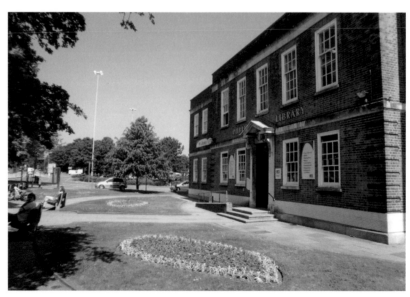

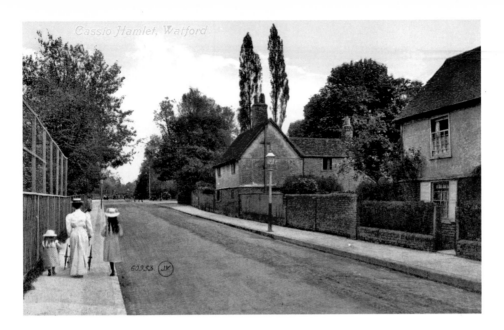

Cassio Hamlet

This quiet Edwardian view of 1908 shows the area known as Cassio Hamlet, which consisted of a small group of cottages just north of the Crossroads and a public house, the Horns. Unaware of the photographer's presence, the small family group in the image – possibly a nanny with her young charges – make their way towards the High Street. It seems difficult to imagine when looking at the modern picture that a hundred years ago horse-drawn haywains used to trundle their heavy loads to market along this very road, now pedestrianised, into Watford. Although the cottages have long since disappeared, the pub is still there, currently enjoying considerable popularity as a live music venue. Soon, throngs of students will spill out of the newly-built West Herts College nearby, as studies for the day come to an end, heading for home or relaxing in the numerous bars and cafés in the vicinity. The Horns can be seen on the right with the Central Public Library just out of view on the left.

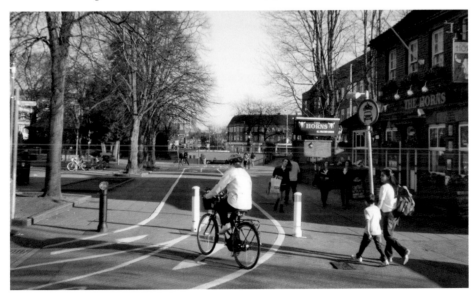

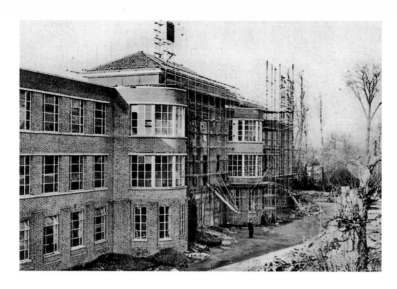

West Herts College

Although the official opening of Watford Technical College, as the campus was then known, took place on 15 May 1953, its history dates from 1874 when premises in Queens Road were used as a library and the School of Science and Art. With the library's eventual transfer to a new building in Hempstead Road in 1928, it was becoming increasingly apparent that the Queens Road site would not provide sufficient accommodation to meet the needs of a technical college. Although construction work commenced at a new location in Hempstead Road just before the outbreak of the Second World War, it wasn't until the late 1940s that the first departments started moving into the partially completed, imposing Art-Deco-style building. Now known as West Herts College, with campuses in Watford, Kings Langley and Hemel Hempstead, a new state-of-the-art structure was opened in September 2010, a short distance from the old premises, which, for the moment, lie empty and dormant. (Top picture courtesy of Watford Central Library).

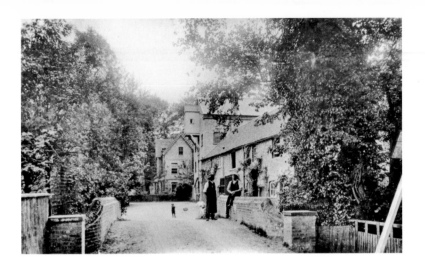

Grove Mill

Apart from the two cars in the picture below taken in the spring of 2011, little change appears to have taken place in this delightful scene at the bottom of Grove Mill Lane where time has almost literally stood still. The focal point of this tranquil setting was Grove Mill, built in 1875 to produce flour for the Grove Estate; the miller and his mill hands living in the adjoining house and cottages. The small wooden structure attached to the top level of the mill was known as a lucum, or sack hoist, where the newly delivered bags of corn were lifted by chain from the cart below. Once the flour had been ground, the reverse process would take place with the sacks being lowered onto the waiting transport for delivery to the estate. Opposite the mill is the Dower House built by the Earl of Clarendon for his mother, the Dowager, Countess of Clarendon. One of the previous owners of this lovely building was Fanny Cradock, the renowned television cook and writer who, together with her partner Johnnie – later her husband – dominated the small screen throughout the 1950s and 1960s with her cookery demonstrations. Following a long period of disuse when the old mill fell into a state of disrepair, it eventually underwent a complete renovation and was tastefully converted into flats during the early 1970s.

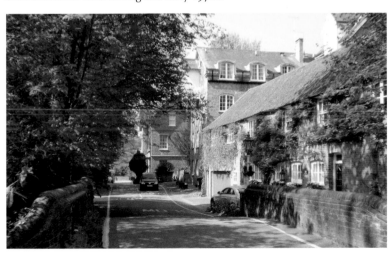

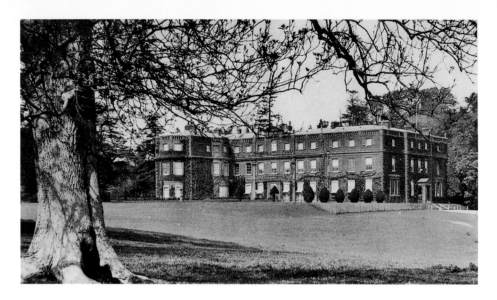

The Grove

Formerly the lovely home of the Earls of Clarendon, this early-twentieth-century card of the Grove was posted on 12 August 1915. Situated in 300 acres of fine parkland and woods, the house is believed to have been built in 1756 by Sir Robert Taylor, although some sources suggest this could have been earlier. When the estate was acquired by Lord Doneraile in 1743, part of the work carried out involved the conversion of an ancient chapel into a kitchen. Legend has it that as a punishment for this heinous act, Lord Doneraile was condemned, on his death, to spend the hereafter riding through the extensive grounds on a phantom horse, accompanied by an equally intangible pack of hounds in pursuit of a ghostly fox, a spectral scene claimed to have been 'witnessed' by many of the estate workers. Following the Earl of Clarendon's move to his London home in the early 1920s and the subsequent sale of the estate in 1936, the Grove has passed through several hands, including a high-class girls' school, where the inclusive fees were described as 'thirty-five to forty-five guineas a term according to age', British Rail, who used the building as a training centre and today, where it enjoys a new renaissance as a luxury hotel, spa and golf resort.

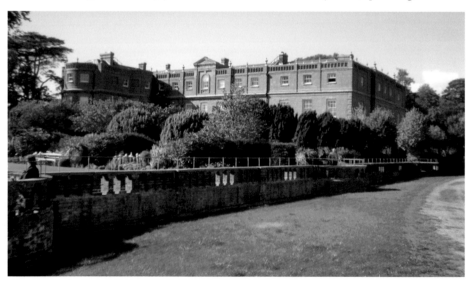

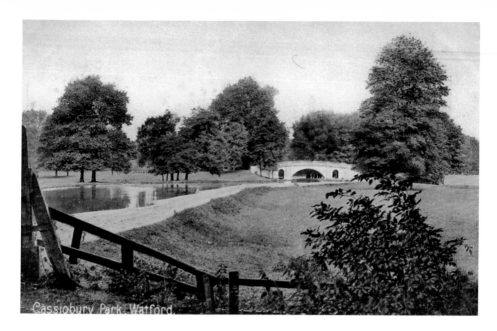

Cassiobury Park. Watford.

Canal Bridge

Straddling the Grand Union Canal in one of the most beautiful stretches of waterway, this lovely early-nineteenth-century, white stuccoed bridge with its distinctive arches on either side, carries the approach drive to the Grove from the main entrance in Hempstead Road. Situated in the picturesque countryside of the Earl of Clarendon's estate, the scene has barely changed in the one hundred years that have elapsed between these two charming images being taken.

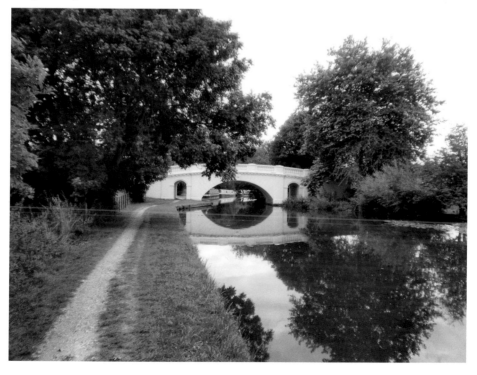

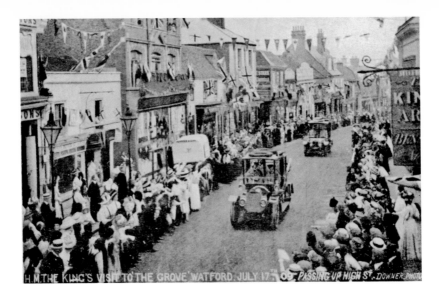

H.M. THE KING'S VISIT TO THE GROVE WATFORD. JULY 17 09. PASSING UP HIGH ST. DOWNER. PHOTO

The King's Visit to the Grove

Watford residents were out in force on Saturday 17 July 1909 to welcome the arrival of King Edward VII, whose small cavalcade of vehicles passed up the High Street on its way to the Grove. Having just motored up from Sandown Races, His Majesty was making a short 'Saturday to Monday' visit, as the weekend was then called, to his friend the Earl of Clarendon. What is most noticeable from this historic image, when compared to modern-day safeguards, is the complete lack of security, as the loyal crowds press forward to cheer and wave their sovereign into the town. Looking at the same vista today, the striking stainless steel and bronze sculpture of a giant Hornet, erected in 2000 as a testament to the long established Watford Football Club and as a celebration of their achievements, stands proudly in front of a branch of McDonald's that now occupies the site on the corner of King Street where the King's Arms public house, just visible on the right above, once stood.

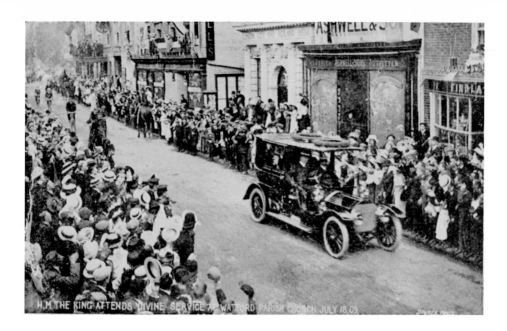

The King Attends Divine Service

The photographer was out again early on Sunday morning, 18 July 1909 to record for posterity the King motoring into Watford to attend Divine Service at the Parish Church, after spending the previous day with the Earl of Clarendon at the Grove. The sender of the above card, which was posted six days after the event on 24 July, excitedly told the recipient, a fellow teacher, that His Majesty had 'expressed a wish that the children should have an extra week's holiday in commemoration of his visit to Watford', a decision no doubt enthusiastically received by the local youngsters. It is interesting to note that the façade of the HSBC, in a picture taken in August 2010, has changed little since the bank was the London City & Midland in the early 1900s. The entrance to Charter Place can be seen between Card Factory and the bank.

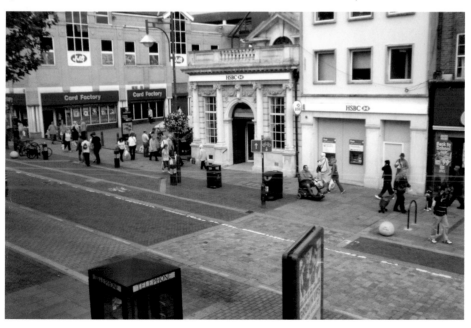

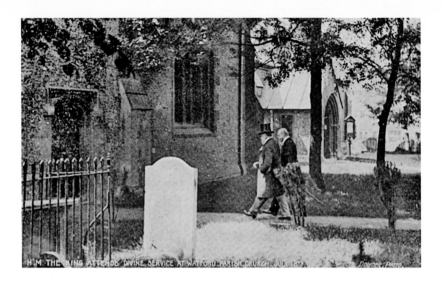

The King Enters St Mary's Church

Taking a short break from his visit to the Earl of Clarendon at the Grove, H.M. King Edward VII is seen here entering the Essex Chapel of St Mary's parish church to attend Divine Service on Sunday 18 July 1909. It was through this small and discreet side entrance that the family coffins of the Earls of Essex were taken before being interred in the vault below. Built on the site of the old church vestry in 1595 by Bridget, the widow of Sir Richard Morrison, who initiated the building of the first Cassiobury House, the chapel contains the beautifully sculptured tombs of some of the Morrison family. The other door that can be seen in the background by the notice board is the North Door where, although the porch is Victorian, the arch of the doorway itself can be traced back to medieval times. Today, the entrance to the Essex Chapel – sometimes referred to as the King Edward VII door – is still there, although an extension to the church at this point now obstructs the original view.

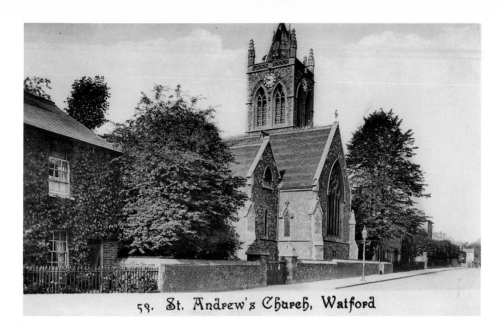

59. St. Andrew's Church, Watford

St Andrew's Church, Church Road

With the opening of the London & Birmingham Railway in 1837 and a need by the company for their employees in Watford to live in close proximity to the station, land was purchased from the Earl of Essex for development. This brought about a steady influx of people into the rapidly growing area of Nascot, and it was decided that this new population needed a church to serve them, the only other Anglican place of worship at the time being St Mary's. The foundation stone of the new church of St Andrew, designed by the noted architect S. S. Teulon, was laid in 1853 with the consecration taking place in 1857. In recognition of St Andrew's close links with the railway, seven old stone sleepers were incorporated into the outside of the west wall. Devotees of television 'soaps' will be interested to learn that the church has been used on a number of occasions for the external location shots of several *Eastenders* weddings.

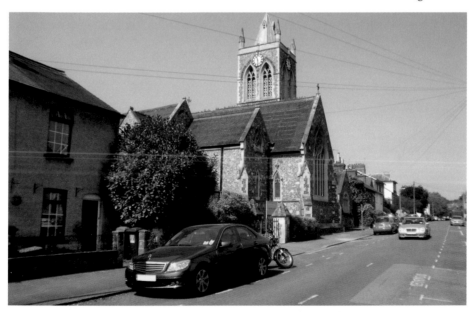

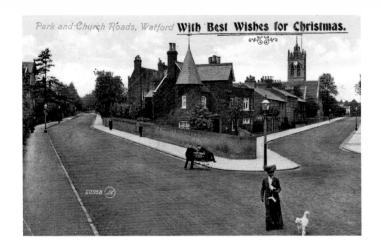

Park and Church Roads, Watford **With Best Wishes for Christmas.**

Park and Church Roads

Without the ubiquitous motor car and road markings, there would be little difference between the turn of the century photograph taken at the junction of Park and Church Roads in Nascot and the 2010 picture. The very distinctive looking property in the centre of both images, at one time known as Cambridge Villa, was constructed in 1847/48 by a miller from Chipperfield called William Stapleton who, after purchasing the land from the Earl of Essex, proceeded to develop the site with two cottages. These were later amalgamated into a single dwelling house by a later owner, one Henry Henson, Gentleman, during the mid-1850s. At various times, the property is known to have been used as a bakery and a school. Just past St Andrew's church and out of sight around the bend in the road are the Salters' Company Almshouses. Built in 1863, the picturesque Gothic style buildings provide accommodation for elderly residents with limited means. One point worthy of mention is that from 1949 until 1991, the ornate wrought-iron gates that stood at the main entrance were originally commissioned for Prince Albert, Queen Victoria's Consort, and subsequently shown at the Great Exhibition of 1862. These were later purchased by the Salters' Company for their Livery Hall in London. Following enemy action in the Second World War when the hall was destroyed, the gates, which survived, were moved to the almshouses in Church Road where they remained until their eventual return to their rightful place at the Salters' Company. A replacement set of gates was later installed at Church Road.

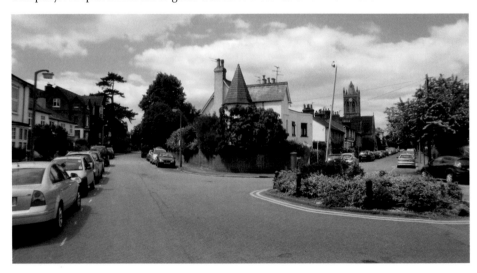

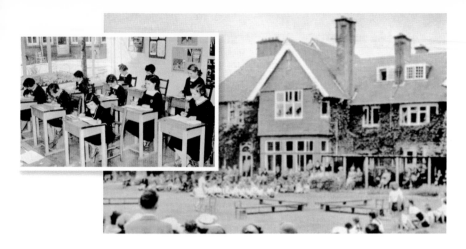

Gartlet School

A summer open day in the genteel surroundings of Gartlet School in Nascot Wood Road is shown above during the Coronation year of 1953, with Form II (*inset*) no doubt grappling with a mathematical logarithm or English précis. The private school for girls was originally founded by a Mrs Walker *c.* 1855 in Bushey, although with the steady increase in the number of pupils, it wasn't long before it was found necessary to relocate to larger premises in Fairfield House, which had been specially built for the school in Loates Lane. Following its transfer to Clarendon Road in 1897, where it remained for over fifty years, the school moved to a lovely house called 'Baynards' in Nascot Wood Road under the guidance of the two joint heads, the Misses Howe and Hancock. With the addition of a gymnasium, library and a new block of Form Rooms, the school thrived, but eventually closed its doors for good in the late 1980s/early 1990s, the premises then being occupied by the award-winning Watford School of Music until they moved to their new home in Clarendon Muse at the boys' grammar school in 2008. The old Gartlet School building is now being converted into luxury apartments, with two lodge houses and additional apartments being constructed in the grounds where once some of the school's outside activities took place. (Top pictures courtesy of Betty Cooper).

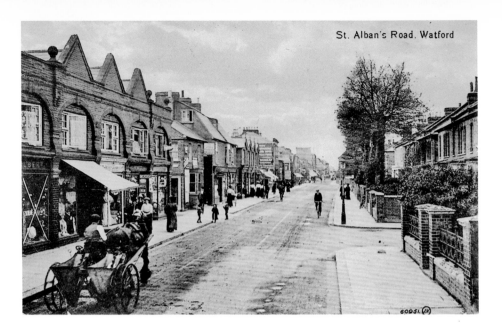

St. Alban's Road. Watford

St Albans Road – Junction with Wellington Road

With the vista changed out of all recognition from those halcyon days just prior to the outbreak of the First World War, the Park Inn Hotel now occupies the site on the corner of Wellington Road where private residences once stood. On the opposite side of St Albans Road, in the extreme left of the picture, can be seen the dual frontage of the gown shop belonging to A. M. Gilbert, White's Bushey Laundry and Hewitt's the tobacconist, where the advertisement indicates that cigars are on offer. A little further along the road on the corner of West Street, behind the small group of children playing on the edge of the pavement, is the Jolly Gardeners public house where, for a great many years during the first half of the twentieth century, the licence was held by the Mendham family. Today, with extensive road widening and redevelopment having taken place, a Kwik-Fit tyre, battery and exhaust centre has now replaced the old pub.

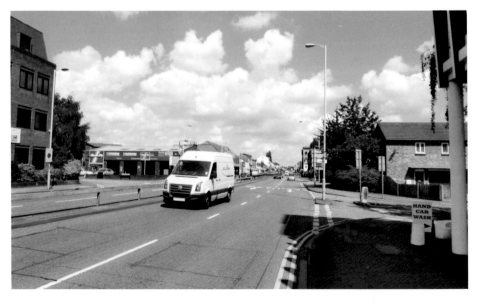

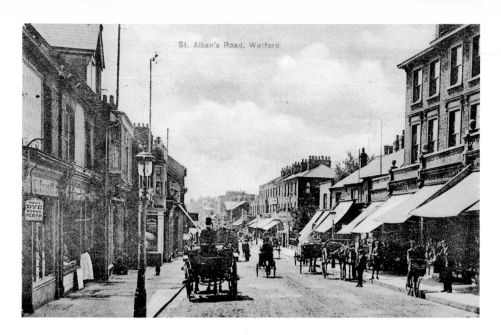

St. Alban's Road, Watford

St Albans Road – Junction with Station Road and Langley Road

This snapshot taken in the early 1900s depicts a fairly busy St Albans Road taken from the bridge looking towards the junction with Station Road and Langley Road. Whilst the buildings on the left have long been demolished to make way for road widening, some of the architecture on the right has survived with little change to the first floor level and above over the intervening years. Although it is virtually impossible to determine many of the shop front names, some of the traders included a dispensing chemist, a corn and coal merchant, a perambulator manufacturer and a bootmaker, 'where repairs were neatly executed'. Coincidentally the sender of the card, a T. M. Coleman, was a resident of St Albans Road at the date of posting on 16 April 1907, living at No. 218, just a short distance away from where the above photograph was taken.

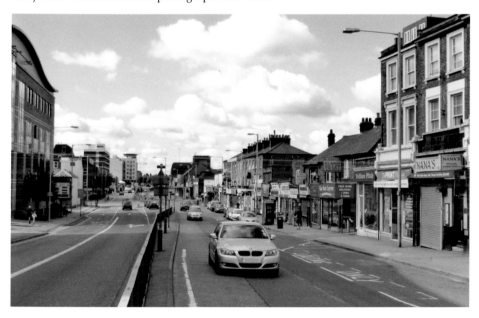

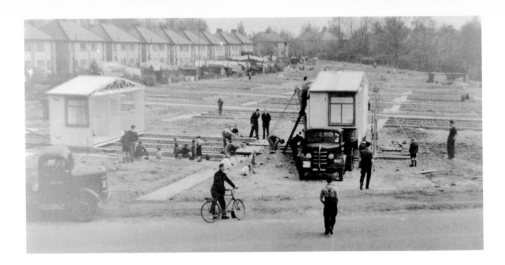

Gammons Lane Prefabs

Tucked away on a small, triangular parcel of land in North Watford is the site of what was the only development of prefabricated dwellings of the type shown, to be erected in the town during the immediate austere aftermath of the Second World War. Built as a temporary measure to help meet the acute housing shortage that existed at the time, the prefabs, with a planned life of only ten years, survived until the early 1960s when Hollytree House, a development of sheltered retirement accommodation, was constructed in 1968. The above picture shows the marked out plot, with the rear of the houses in Chilcott Road on the left and Courtlands Drive in the foreground. Gammons Lane is just out of camera-shot on the right. The first of the single-storey factory-built units can be seen being placed in position to await the delivery of further panels and final assembly. With two bedrooms, a bathroom with flushing toilet and fitted kitchen, the prefabs were to many occupants used to the pleasures of an outside lavatory and tin bath, the absolute epitome of 'luxury'. The autumn 2010 image depicts Hollytree House from the same vantage point.

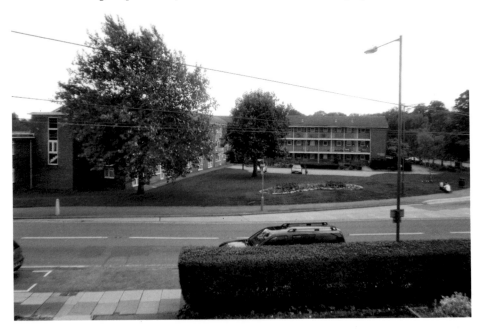

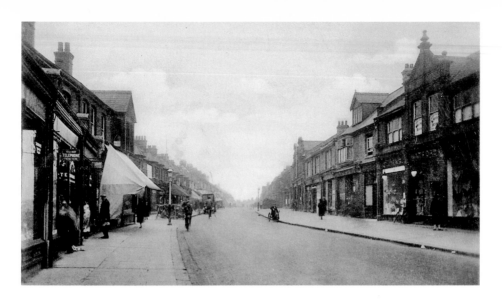

St Albans Road – Junction with Lowestoft Road

Taken in an age when very few people had a telephone of their own, not only private subscribers but many businesses as well, this 1920s image of St Albans Road at the junction with Lowestoft Road shows one of the shops displaying a sign that 'You may telephone from here', which was probably an extremely useful if somewhat limited service in those early days. Coincidentally at the time, there were two branches of the Watford Co-operative Society trading in this part of St Albans Road almost opposite each other. One store was at Nos. 187 & 189, just past Lowestoft Road, and the other one on the extreme right of the picture was at No. 138, later extended as Nos. 136 to 152, where no doubt members could queue for their twice yearly dividend or 'divi' as it was called, paid as a reward to loyal shoppers. With the last occupants of the building being a Carpet Supermarket, now closed, the vacant premises await an uncertain future.

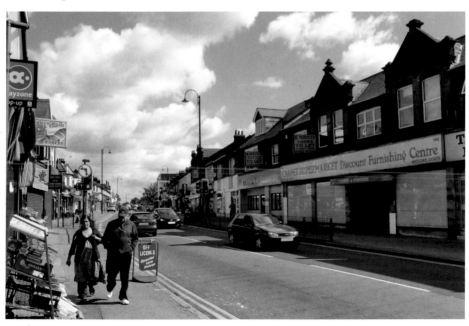

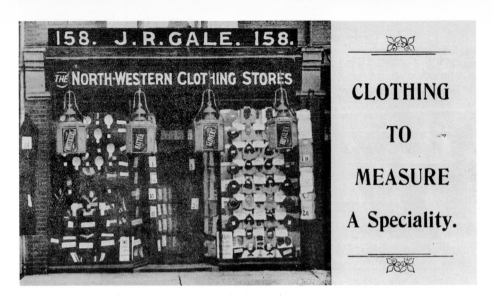

CLOTHING TO MEASURE A Speciality.

The North-Western Clothing Stores

In the 1930s, The North-Western Clothing Stores at 158, St Albans Road proudly boasted a Bespoke Department where 'Clothing to Measure' was cut by 'experienced cutters and made by practical workmen' with 'all the most fashionable cloths for the present season'. Suits could be purchased from 21/6 to 75/-. For the less discerning, their Ready Made Department could cater for the needs of 'workmen's, engineers' and butchers' clothing'. In addition, the extensive selection of goods on offer included items ranging from calicoes, sheetings and linoleums to umbrellas, hosiery and collar studs - literally a mini emporium. A convenience store now occupies the premises, and although the stock may be different, still provides the same comprehensive and valuable service to the local community that was on offer by Mr Gale over seventy-five years earlier.

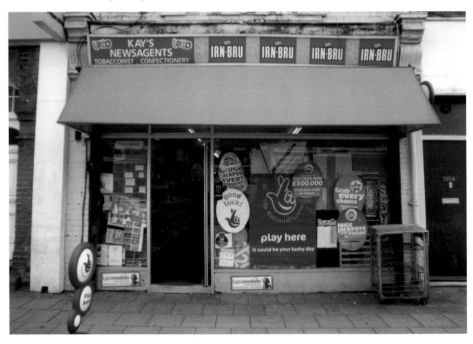

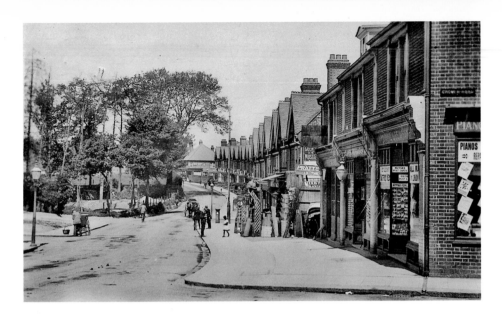

St Albans Road – Junction with Cromer Road

This superb postcard from the summer of 1915 shows a St Albans Road, frozen in time, at the junction with Cromer Road, although today there is now no longer any access onto the main thoroughfare. On the right-hand side, the shop on the corner that undertakes piano repairs has what appears to be a selection of sheet music on display, whilst the window to the side of the entrance door is advertising the sale of 'Picture Post Cards' with a wide selection of 'Watford Views' available. Who knows, it may even have included the one depicted above! Further down the road, an ironmonger's wares of washing baskets and a besom of twigs have spilled out onto the pavement, together with a sturdy looking trelliswork arch and some rolls of wire netting. The turning on the right by the pillar box is Balmoral Road.

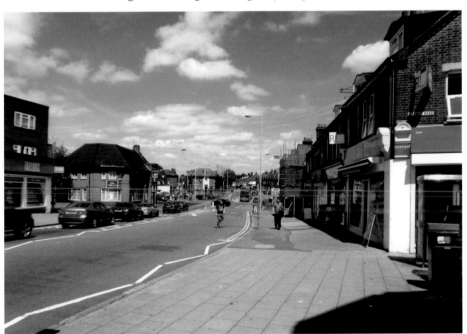

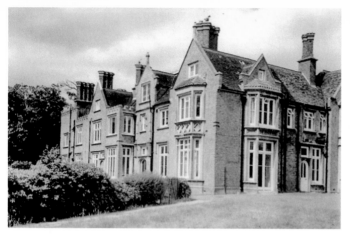

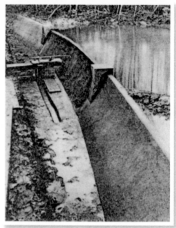

Mohne Dam

Bucknalls, a lovely mid-nineteenth-century mansion built in 1855 in the rolling countryside just to the north of Watford was, in 1925, acquired by the then fledgling Building Research Station, now the Building Research Establishment (BRE), one of the foremost organisations in building research, consultancy and testing in the world. It was here in a remote wooded part of the site during the dark days of the Second World War that preparations for Operation Chastise, more commonly known as the Dambusters Raid, were carried out when on the night of 16/17 May 1943, nineteen modified Lancaster bombers of No. 617 Squadron RAF Bomber Command attacked the German dams in the heart of the industrial Ruhr using the famous bouncing bomb designed by Barnes Wallis. A 1:50 scale model of the Mohne Dam in Germany was constructed at BRS to resolve the problems of where to hit the dam and with how much explosive. The top right picture shows the Mohne Dam model ready for the first test on 22 January 1941. The bottom image depicts the dam as it is today. The photograph has been autographed by the late actor, Richard Todd, OBE who starred in the 1954 film, *The Dambusters*. (Top pictures courtesy of BRE).

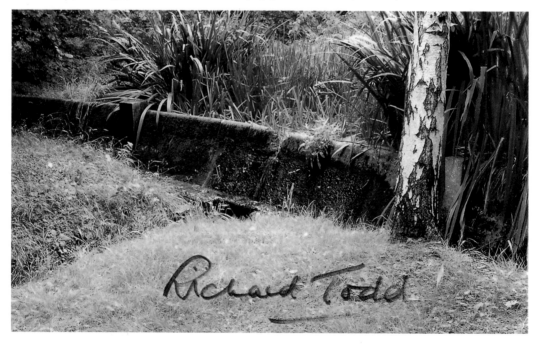

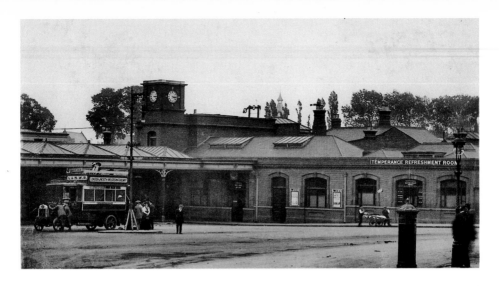

Watford Junction

With the arrival of the London & Birmingham Railway through Watford in July, 1837, a station was built that same year on the north side of the bridge in St Albans Road, where 'every arrangement was made for the comfort and convenience of passengers'. Twenty-one years later in 1858, with the addition of a third track nearing completion, a branch line to St Albans under construction, and with no space to accommodate extra platforms, a new station was built on the site that it occupies today. As there was no subway in those early days, access to the platforms was by way of a ramp. Further work was carried out on the station in 1909 when the front was extended and rebuilt. A new Watford Junction with office facilities replaced the old one in 1985. Of historical interest, part of the old Grade II listed station at 147a St Albans Road can still be seen, where the premises are now occupied by a second-hand car dealer.

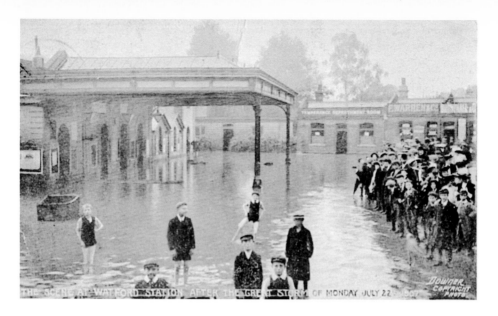

Floods at Watford Station

The presence of the photographer has certainly attracted an inquisitive crowd of onlookers as these youngsters, no doubt at the start of the school holidays, enjoy a summer paddle in the station forecourt after what was called 'The Great Storm of Monday 22 July 1907'. The offices of the coal merchants, Brentnall & Cleland Ltd can just be seen to the right of the picture, with the Temperance Refreshment Room next-door-but-one also appearing to be experiencing the aftermath of the flood. Over one hundred years later, with the station having been completely rebuilt, the view is now totally unrecognisable.

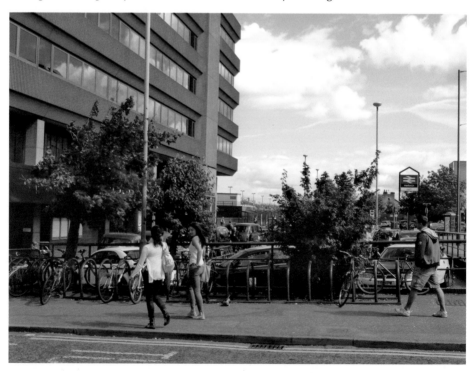

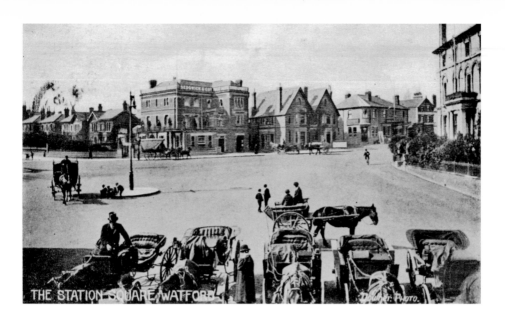

The Station Square

It is difficult to imagine that where horse-drawn carriages and their drivers once lined up in what was captioned 'The Station Square', probably in some cases waiting for the head of their particular household to arrive on the next train from London, taxis now queue to transport home some of the commuters who will shortly stream out of the Junction entrance. When looking at how the vista appears today, the whole area in the earlier photograph looks positively vast with the absence of road markings and long before major building work was carried out on the station. The scores of bicycles chained to the railings are also a tell-tale sign of the preferred mode of transport for many in getting to and from the Junction, when compared to that of the prohibitively high cost of using a car. The old Clarendon Hotel, formerly the Pennant and now the Flag public house, can be seen on the right-hand side of both images.

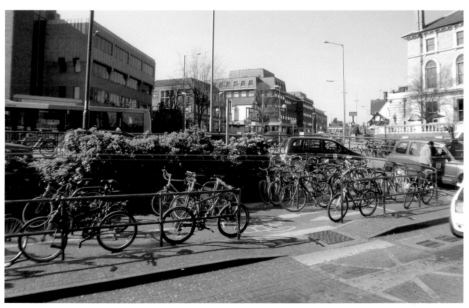

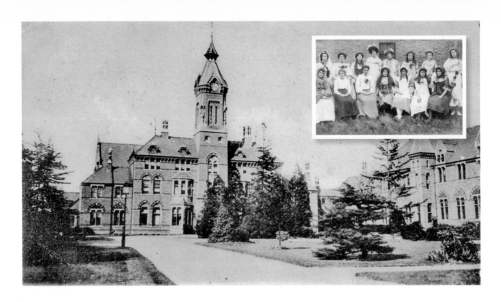

London Orphan Asylum

The London Orphan Asylum, originally in Clapton, was founded in 1813 by Andrew Reed as a charitable organisation 'to educate respectable fatherless children of either sex'. With concern for the poor health of the children, it was decided to construct a new institution in Watford, deemed a healthier environment, which was opened in 1872 by Princess Mary of Cambridge, the Duchess of Teck. The card (*inset*), postally used on 2 July 1905, shows some of the staff at the Asylum, which was renamed the London Orphan School in 1915 and Reed's School in 1939. During the 1980s, the beautiful buildings were converted into private accommodation.

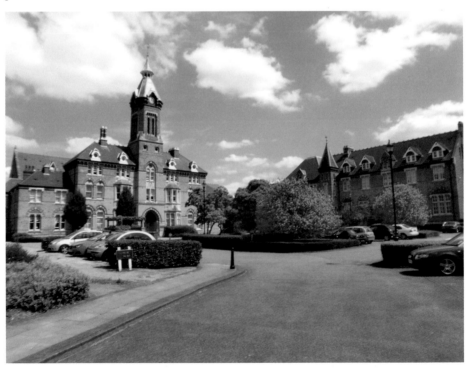

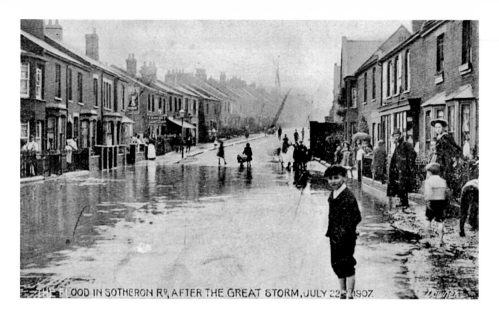

FLOOD IN SOTHERON R?, AFTER THE GREAT STORM, JULY 22ND 1907.

Sotheron Road

The Great Storm of July 1907 certainly gave the residents of Sotheron Road something to chat about as they gathered to view the after effects of the deluge, although the presence of the photographer probably created a great deal more interest. One wonders though whether these youngsters would have been quite so bold splashing in the shallow water had the downpour not taken place in the summer holidays, for as luck would have it, one of their neighbours was Mr William Bristow, the School Attendance Officer who lived at No. 51! This narrow thoroughfare of late Victorian villas runs from Sutton Road at the top, where the distinctive spire of St John's church can be seen on the horizon, to the junction with Woodford and Queen's Roads at the bottom. Tom Cheney's sign advertising his coach building establishment can be seen on the left at No. 73 whilst at No. 37, Miss Sophia Swabey carried out a reputable dressmaking business from her home.

Town Hall Roundabout

Taken in the mid-1950s, this picture of the roundabout at the junction of the High Street with Rickmansworth, Hempstead and St Albans Roads seems remarkably traffic-free for the middle of the day. One can be certain from the time shown on the Town Hall clock, that the image was captured at lunchtime, possibly a Sunday. What a difference the same view looks today following the implementation of a major road construction programme in 1972, and the pond area of the High Street now pedestrianised. Dominating the foreground in the 2010 image is the impressive modern street-art structure called 'The Memory Wall'. Created in 2000 by a local artist and installed as part of a Lottery-funded project, the Wall consists of a metal framework containing approximately 600 glass and resin blocks, each which have been embedded with an object or message by more than 200 of Watford's residents. This internally-illuminated sculpture forms a unique landmark at the north end of the town, where so much change has taken place since the above snapshot was taken that Sunday lunchtime over fifty years ago.

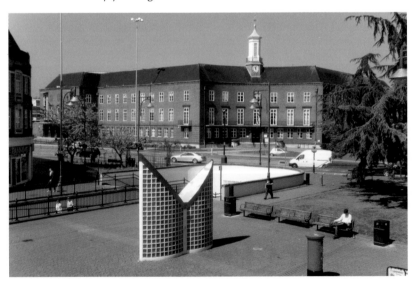

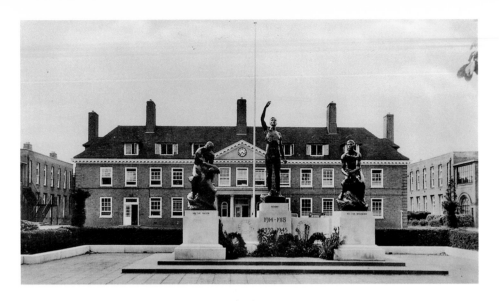

Peace Memorial Hospital, Rickmansworth Road

Opened in 1925 by The Princess Royal at a cost of £90,000, the Peace Memorial Hospital was built to replace the old Cottage Hospital in Vicarage Road, although by the late 1930s even this new accommodation was found to be inadequate to meet the needs of a fast-expanding area. In response to an appeal, a further £70,000 was raised by generous public subscription to provide much needed extensions. In July 1928, a splendid statue of three figures sculptured by Mary Pownall Bromet and dedicated 'To the Fallen', 'Victory' and 'To the Wounded' was unveiled by the Earl of Clarendon. Known as 'The Spirit of War', the statue is now situated by the Town Hall. With the expansion of the West Herts Hospital in Vicarage Road, the Rickmansworth Road site eventually closed, and although much of the old hospital infrastructure has now disappeared, the original building remains as the Watford Peace Hospice.

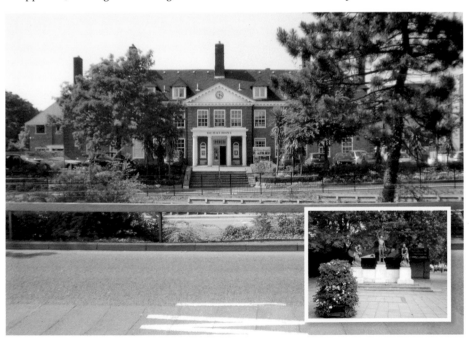

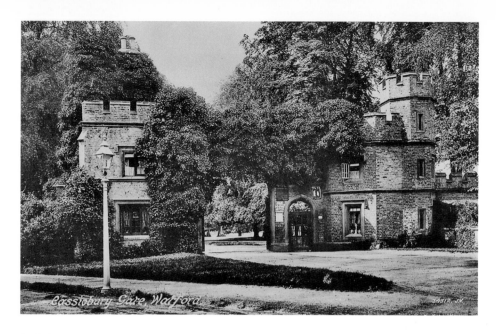

Park Gates

Friday, 24 July 1970 was indeed a black day for Watfordians when the demolition men started to reduce a piece of Watford's heritage to rubble. The historic, castellated, Tudor-style Lodge Gates giving access from Rickmansworth Road to the lovely Cassiobury Park, were originally built as the entrance to the long driveway leading to Cassiobury House but, due to an 'essential' road widening scheme, their fate was sealed and they had to go, an act neither forgiven nor forgotten by Watfordians. Where the gates once stood, now proudly flutters a Green Flag from its pole. The prestigious award, only granted to those parks that have met a set of key criteria, has flown at the entrance to Cassiobury, literally the jewel in Watford's crown, for four consecutive years since 2007.

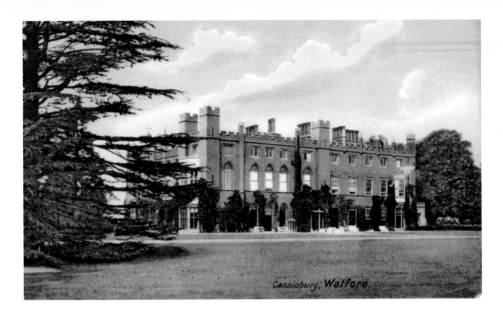

Cassiobury House

Pictured in the early 1900s, it is difficult to imagine that twenty-five years later this magnificent mansion, Cassiobury House, seat of the Earls of Essex, would be no more. Situated near Temple Close and the tennis courts on what was once the Cassiobury Estate, the House had been built and rebuilt several times since its original construction was commenced by Sir Richard Morrison in the mid-sixteenth century. Following the death in 1916 of George Devereux de Vere Capell, the seventh Earl, his wife Adele, the Countess Dowager of Essex sold the estate in 1922 but with no purchaser for the house, it was left empty and derelict for a further five years until its demolition in 1927. As was to be expected, there was a considerable amount of building materials to be disposed of and these were sold by auction on site on Wednesday 9 November 1927 – the end of an era.

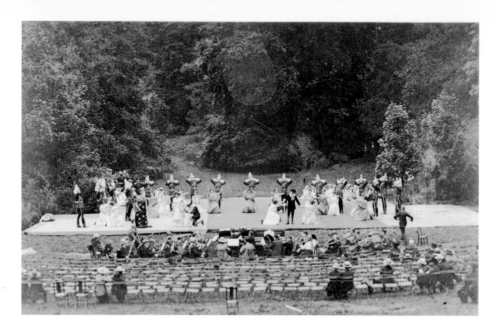

Leisure Activities in the Park

Over the years, Cassiobury Park has been host to numerous activities and events. Celebrations such as those marking the coronation of King George V in June 1911 and later, the annual Whitsun Carnival, with its procession of decorated floats and marching bands meandering through the streets of Watford to finish in the park, where the crowds of enthusiastic spectators were entertained to an extravaganza of horse show jumping and sheep dog trials, marvelling too at the skills shown on the exciting motorcycle displays. The early postcard above dated 18 August 1920 shows what appears to be a musical play or operetta and is entitled 'Spiele (Games) in Cassiobury Park', although judging by the attendance does not appear to be too popular! Today, more energetic pastimes are pursued as countless people of all ages participate in events such as the Race for Life, the 10km Charity Run or, as depicted below, the Watford Marafun where competitors can sometimes enter in fancy-dress, such as 'Tweedle Dum' and 'Tweedle Dee' who are just approaching the winning post.

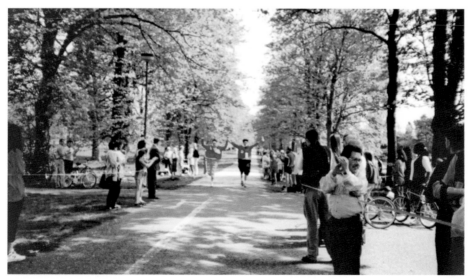

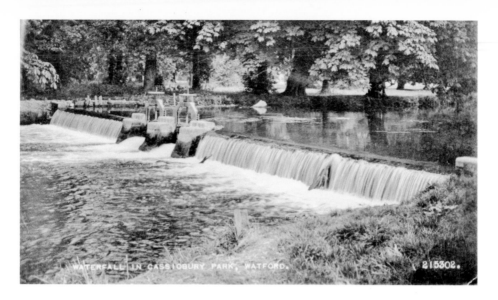

Sluice Gates

Probably one of those small landmarks in the park that everybody sees but nobody really notices. Situated just down river from the children's play area is a weir with two sluice gates as seen in the above card posted in 1951. The structure was placed in this location to hold back a head of water to supply the nearby cress beds with a top-up should the artesian wells/springs ever fail, as they did on occasion. How then did the weir operate? The owners of the cress beds would check the water flow into the beds, regulating it accordingly by operating a screw-threaded shaft with a hand-controlled wheel on top of the gates. The gates were then opened and closed by turning the wheel, thus enabling the water to pass over or under the gates, thereby raising or lowering the water levels. For example, if they were planting out, it was better to lower the water level and then raise it to the required depth on completion of the work. As cress is a very delicate plant, the water depth and quality was critical around 6 inches plus. Today the cress beds are no more, with the river's flow now reduced to a narrow channel as gradually vegetation and reeds take hold which helps to protect wildlife and improve their wetland homes.

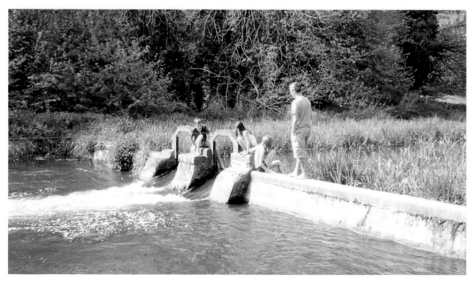

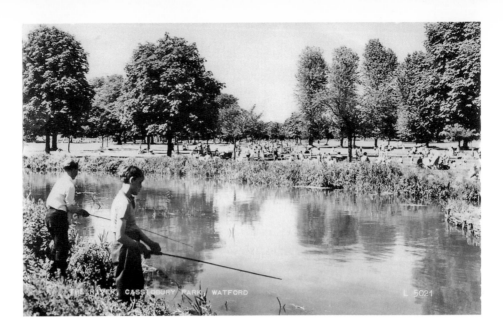

Gone Fishing!

An idyllic picture of childhood innocence, when simple pastimes such as angling in the River Gade helped to pass the long, hot, lazy days of summer. Of course if you were very lucky you might just catch a roach, which could weigh in at a respectable 2lb, but more than likely it was a small minnow that took the bait at the end of the hook. Taken over fifty years ago, the image above shows the old paddling pool on the opposite bank of the river which, like today, always attracted crowds of excited youngsters, eager to splash in the cool water or to sail a toy yacht. A modern play area and a cluster of new pools complete with fountains have now replaced the outdated facilities, ensuring that the comprehensive amenities on offer are as popular as ever to the thousands of visitors from far and wide who come to the lovely award-winning park each year.

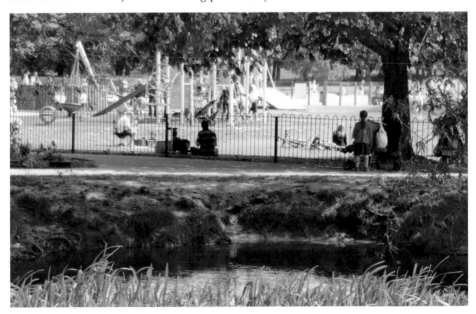

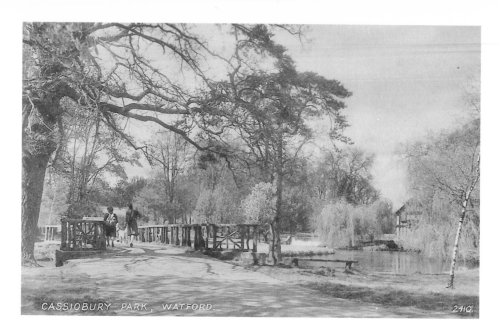

River Gade

Time appears to have stood still in these delightful images of the River Gade, and yet over half a century has elapsed between them. The lovely view above shows the Old Mill on the right, now long demolished, with two walkers on the bridge probably heading for the nearby Whippendell Woods or perhaps a stroll along the towpath of the Grand Union Canal a short distance away. The modern-day picture, taken in April, 2011, shows just how much the trees have matured during the intervening years.

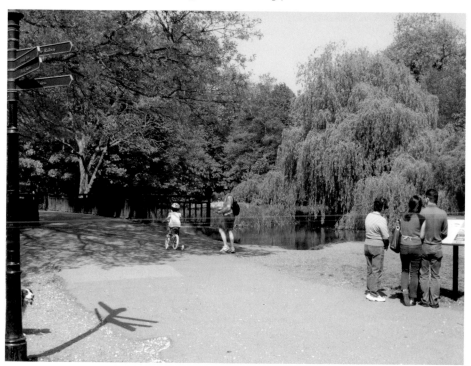

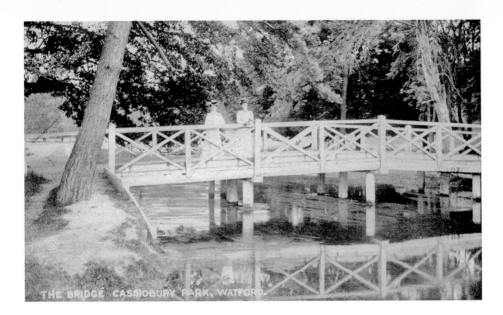

THE BRIDGE CASSIOBURY PARK, WATFORD.

Rustic Bridge

Like the two exquisite Edwardian ladies posing for the photographer on a warm summer's day, the visitors to the Park in the 2011 image are taking the opportunity to enjoy the spring sunshine on the footbridge over the River Gade. Now known as the Rustic Bridge, this beautifully hand-carved wooden structure depicts various examples of the flora and fauna that exists in the parkland and around its waterways, much of which can be discovered by taking the Cassiobury Park nature trail or exploring the wildlife reserve.

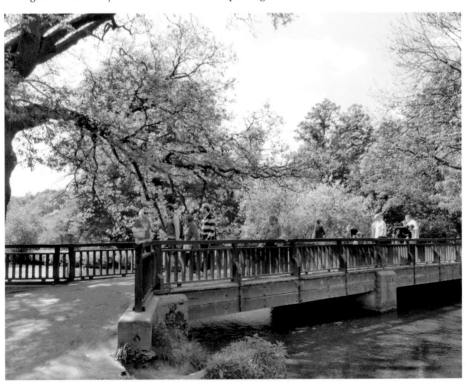

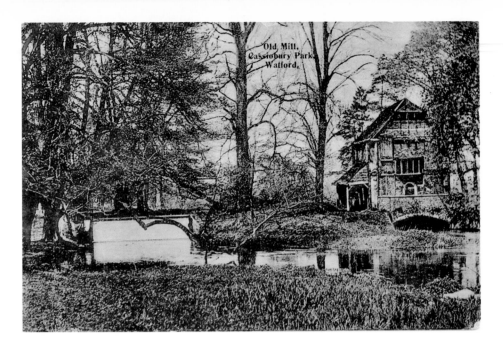

The Old Mill

Hidden amongst the trees next to the weir at the bottom of Cassiobury Park is the site of the Old Mill, once used to grind corn and later utilised for the pumping of water to Cassiobury House. Following the demolition of the mansion in 1927, the mill fell into a state of disrepair and in 1956 was eventually knocked down and removed, although after more than fifty years there are still signs of this historic structure to be seen. In the early spring before the foliage and undergrowth start to grow, some of the foundations are just visible from the opposite river bank, whilst the brick arches over the mill stream, as seen inset (below), are even now very much in evidence – a small remnant of a bygone age.

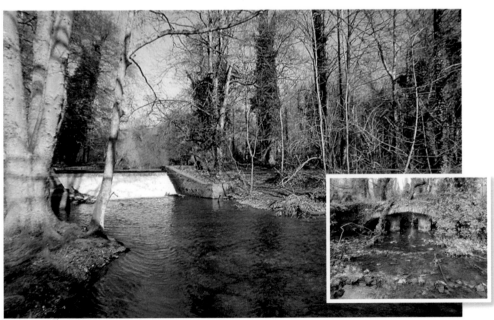

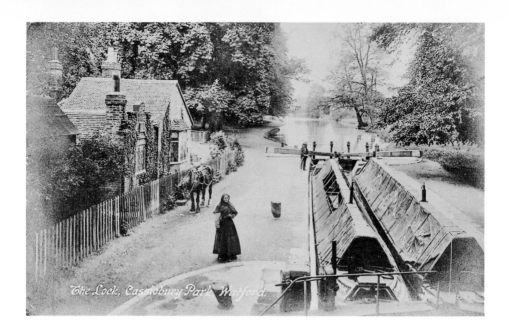

Lock Cottage

The tow horse is obviously enjoying his nosebag of feed and a well earned rest in this charming postcard sent on 24 July 1913. Originally known as the Grand Junction Canal, part of the waterway system connecting London and Birmingham, the company was bought by the Regent's Canal in 1927 before amalgamating with several other companies to form the Grand Union Canal in 1929. Where once the narrow boat was used solely to transport coal and other commodities, today's modern craft, such as the one seen in Cassiobury Park's Iron Bridge Lock, attract numerous people each year for holidays and weekend breaks. Although the cottage has now gone, the area nevertheless is one of the most attractive parts of the waterway.

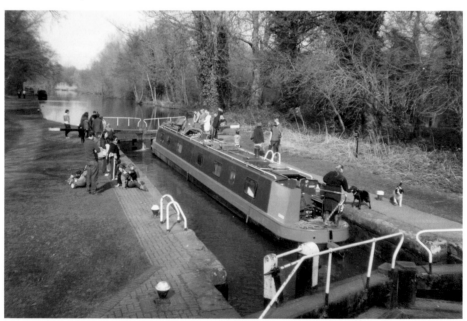

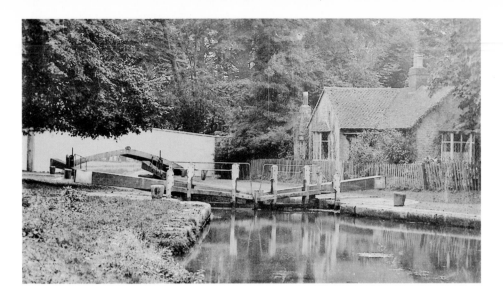

Iron Bridge Lock

Situated on one of the loveliest sections of the Grand Union Canal where it meanders through the beautiful Cassiobury Park is Iron Bridge Lock No. 77. A popular venue for visitors to the Park throughout the year, the adjacent Bridge No. 167 provides an excellent vantage point from which to watch the narrow boats passing through the lock. Although some of the boats are on hire, many more are privately owned. Some of these boat people, or 'boaters' as they call themselves, live all year round on the water and are justifiably proud of their floating homes and their way of life, forming a close tightly-knit community wherever they are moored.

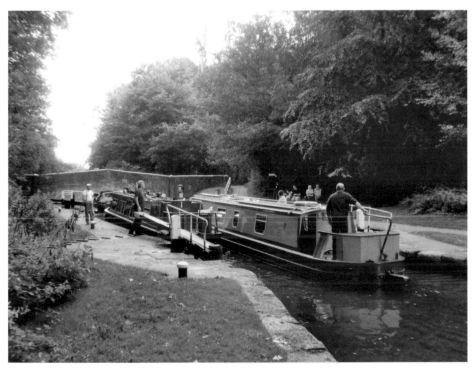

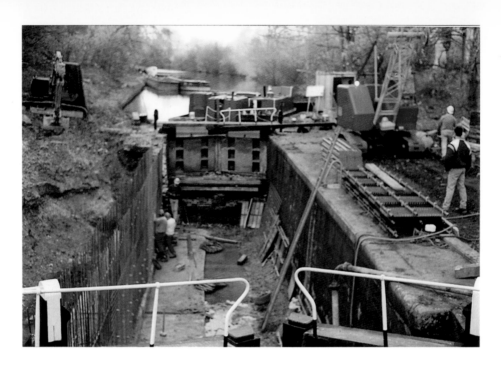

Iron Bridge Lock Under Repair

During the summer of 1991, the towpath side of the lock wall became extremely unstable. In order to keep the navigation open during the boating period, the structure was stabilised in the short term with the lock wall rebuild scheduled for November of that year. The works consisted of removing the old brickwork and replacing it with a steel reinforced concrete wall, with the job carried out over a seven week period. The bottom picture shows 'it's business as usual again'. (Top picture courtesy of Cynthia & John Morgan).

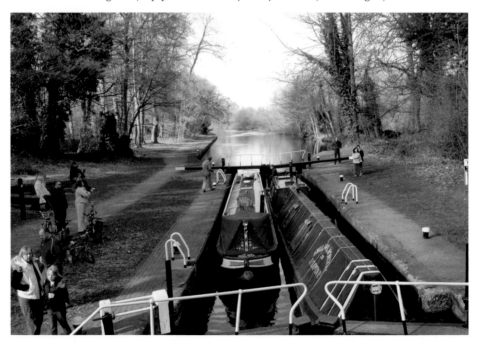

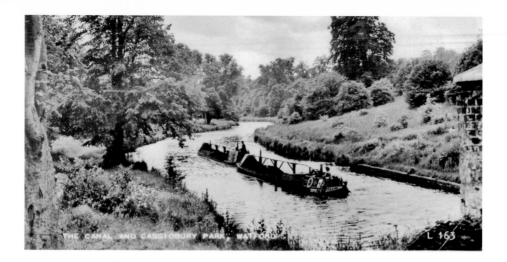

The Canal

A gradually disappearing way of life is depicted here in this old postcard of two working narrow boats travelling along the cut, as the canal is sometimes called, through the lovely Cassiobury Park. With steam and diesel replacing the tow horse in the early 1900s, it was possible to carry extra cargo by towing a second unpowered boat, called a 'butty'. Further back along the canal towards Grove Mill, in close proximity to each other, are Locks 75 and 76, known as 'Albert's Two' on account of one Albert Evans who was the lock keeper there for a great many years in the 1930s. The modern image of the pretty nineteenth-century cottage portrays a peaceful way of life which today is just a memory, and although there are no essential utility services, with water obtained from a well, this must surely be one of the most idyllic spots locally in which to live. With more and more people seeking an active and yet tranquil way of spending their retirement, probably the name of the narrow boat, *Ternstaw* entering Lock 76 tells it all, as the word is an anagram for 'New Start'.

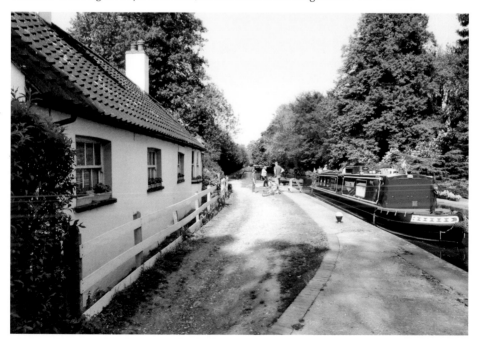

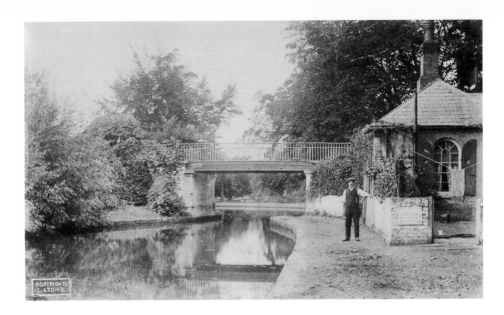

Grove Mill Bridge

It seems barely possible that eighty years separates these two tranquil pictures of Grove Mill Bridge (No. 165) with very few obvious changes having taken place. The small house on the right is Canal Cottage built *c.* 1800 by the Grand Junction Canal Company as accommodation for one of their employees. It was his job to collect tolls from passing narrow boats and to ensure that there was an adequate supply of water to the nearby Grove Mill. The above image would have been taken in the late 1920s/early 1930s with the man in shirtsleeves almost certainly the occupier of the cottage.

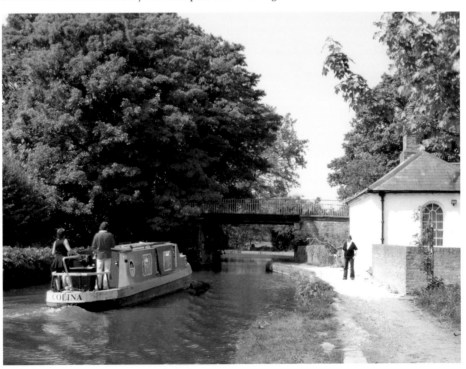

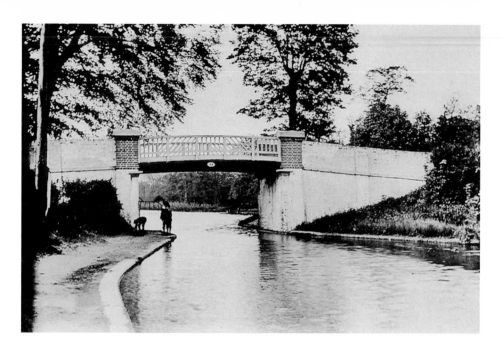

Canal Bridge No. 168

This lovely old bridge over the canal is situated just a short distance from Cassio Wharf, a narrow boat marina near the busy Rickmansworth Road. The bridge can be reached in one direction only by car via a leafy lane that meanders down from Croxley Green, running parallel with the prestigious West Herts Golf Club where it then peters out. Pedestrians can then walk the short distance through the woods, where the foliage of low hanging trees and fronds of thick, green vegetation are draped in the stagnant pools and small waterway tributaries, to the footbridge over the River Gade into Gade Avenue, passing *en route* the Rousebarn Fishing Lake and one of the old disused watercress beds, a reminder of a long-forgotten local industry.

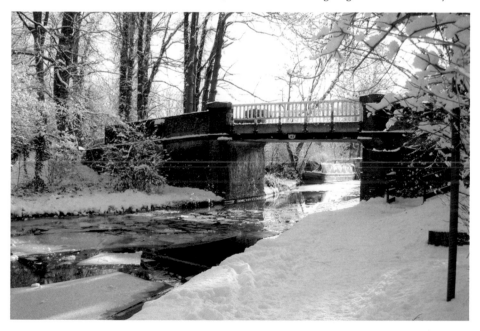

The Bandstand

Each Sunday throughout the summer months, the rousing marches of John Philip Sousa and other well-known composers could be heard echoing around Cassiobury Park as a military band played to a captive audience from the fine Edwardian bandstand situated near the path leading to Stratford Way. For 3d, the price of a deckchair, one could sit and relax; listening to the music and watching the world go by. This quintessentially English pastime continued until the late 1930s when, with the outbreak of the Second World War, the bandstand fell into disuse. It was eventually dismantled, and after several years was re-erected in the precinct opposite the Town Hall next to the Central Library. Nowadays, during July and August, the old bandstand comes to life again as local groups and young musicians entertain a new and equally enthusiastic gathering of spectators.

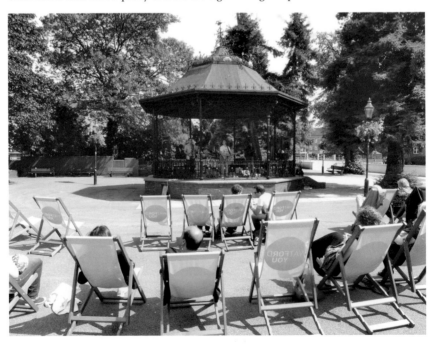

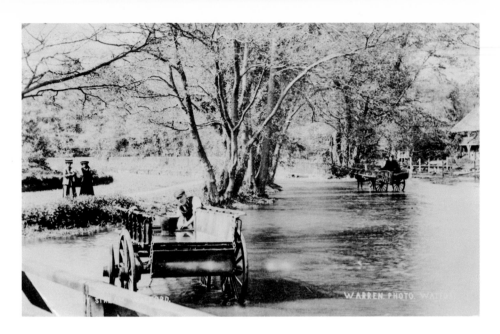

The River Gade and Swiss Cottage

Reminiscent of the famous painting, 'The Haywain', by John Constable, this turn-of-the-century image shows a farm worker washing down his cart in the river on a hot August day whilst no doubt his horse is quietly grazing nearby. To the right of the picture can just be seen Swiss Cottage built in the traditional chalet style and long since destroyed by fire. The cottage was once described by John Britton when writing on Cassiobury in 1837 as a dwelling 'on the bank of the River Gade, intended for the occupation of a family, and the accommodation of parties during the summer to take refreshment'.

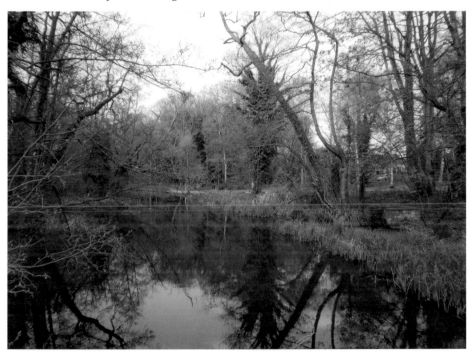

Watford Metropolitan Station

The station in Cassiobury Park Avenue, seen here under construction, was opened on 4 November 1925 as part of the extension from Moor Park. Although the branch line ends at Watford, it was initially intended, but never constructed, to continue into the town centre as Watford Central. The original station building in the High Street opposite Clarendon Road is now occupied by a public house. Preliminary discussions though are now being held with regards to the proposed Croxley Rail Link that would take the line from Croxley Station via a new route onto the disused Croxley Green branch line. This would involve the construction of two new stations at Ascot Road and Watford Hospital before terminating at Watford Junction. Unfortunately, the proposed scheme will mean the possible closure of the existing Metropolitan Line Station, a devastating blow to local commuters and the many schoolchildren who use the line.

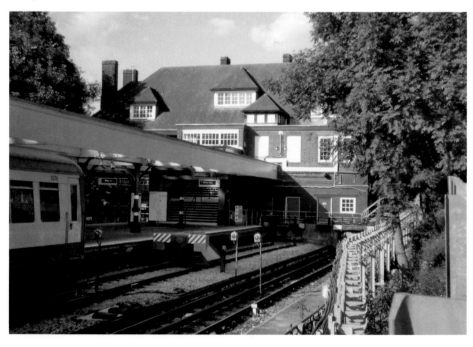

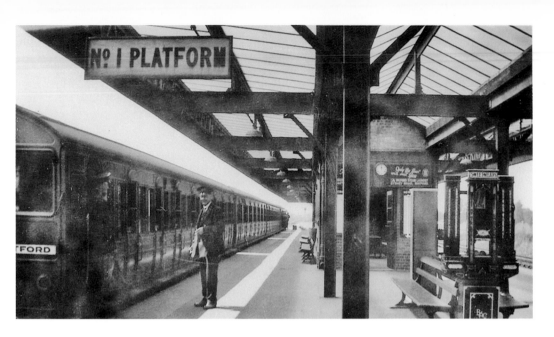

No. 1 Platform – Watford Metropolitan Station

An early photograph of one of the platforms at Watford Metropolitan Station, probably shortly after the station's opening in 1925. Note the slot machine advertising the sale of sweetmeats on the right of the picture. Below, the same platform today as schoolchildren race to catch their train before its imminent departure.

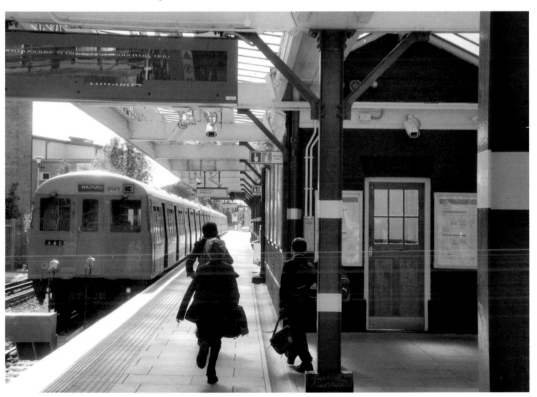

Rickmansworth Road

A single motor car can just be seen in the distance of this real photo card postally used on 15 July 1926 depicting the junction of Rickmansworth Road with Hagden Lane. Ricky Road, as it is popularly known, was one of the earliest roads to pass through Watford and formed part of the Reading and Hatfield Turnpike Trust, created in the mid-1700s. At the bottom of Hagden Lane, known as Cherrydale Hill, stood a gate called the 'Hagney' Lane Turnpike. In 1865, the toll-collector, or pikeman, was fined 40 shillings plus 25 shillings costs, an enormous amount in those days, for demanding 4 1/2d more than was due. One can only assume that the rogue learnt the error of his ways from this extortionate fine!

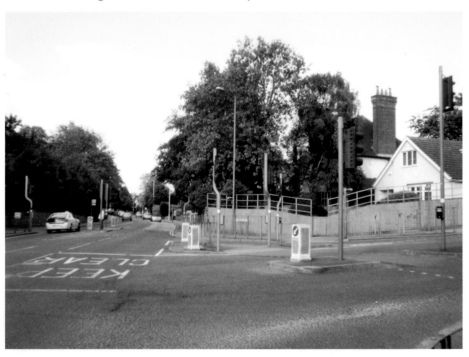

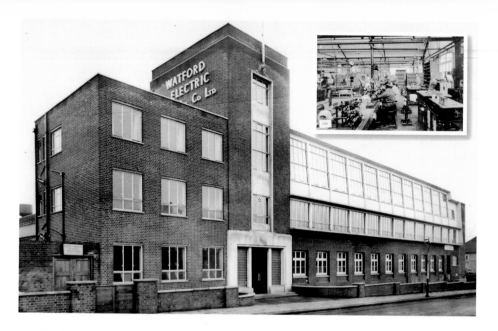

Watford Electric & Manufacturing Co. Ltd (Wemco)

Watford Electric & Manufacturing Company, popularly known as Wemco, was started in 1900 in the West Watford area of Whippendell Road, although its origins can be traced back to the firm of Thomas Kesnor in Fulham during the latter part of the nineteenth century. Many changes have taken place over the last hundred years, particularly the evolution of the distinctive frontage. During this time the firm has earned a reputation for high quality custom-built control gear, although during those early days in Watford, business was mainly concerned with perfecting models in connection with new inventions such as ticket issuing machines for railway stations and rope pulleys. Today the company, now called Whippendell Marine Ltd, is a leading supplier of electrical systems to the Royal Navy. The inset image (*top right*) shows one of the workshops in 1936. (Top two pictures courtesy of Whippendell Marine Ltd, formerly known as Watford Electric & Manufacturing Co. Ltd (Wemco)).

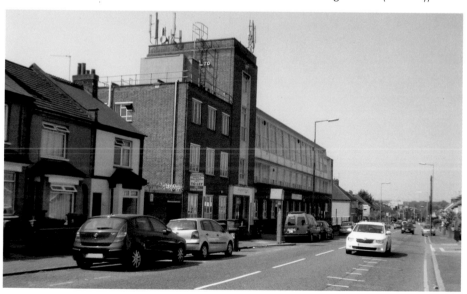

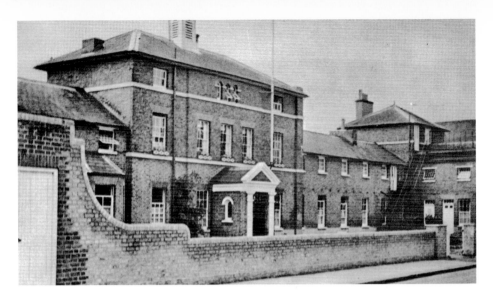

Shrodells

Constructed in 1838 as the Union Workhouse, this rather grim looking early Victorian building in Vicarage Road with its prison-like appearance used to serve the basic needs of the poor within the parish, where they could obtain one good meal a day and a bed for the night. In return, adults and young children were hired out to households and local factory owners to undertake a range of menial tasks, very often for long and arduous hours. In 1930, the name 'Shrodells' (meaning 'shrubberies') was adopted when the Board of Guardians was replaced by the Watford Guardians Committee. The old Grade II listed institution now forms part of Watford General Hospital and is currently used for human resources and training purposes. (Top picture courtesy of Watford Central Library).

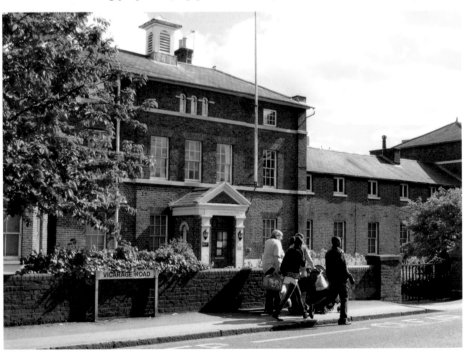

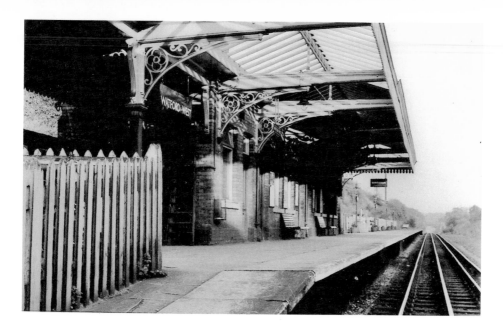

Watford West Station

Watford West Station in Tolpits Lane as it used to look and as it appears today. Only the concrete platform remains, the rusting tracks where once steam trains travelled, now overgrown with undergrowth and flora. The station was opened in 1912 as part of the Croxley Green branch line which ran from Croxley Green to Watford Junction, via Watford West, Watford Stadium and Watford High Street. The station was temporarily shut in 1996 together with the remainder of the line, but was eventually closed permanently in 2001. With discussions taking place regarding the proposed Croxley Rail Link and the possible re-opening of the old branch line, Watford West could again enjoy a new revival, albeit in all probability under a new name.

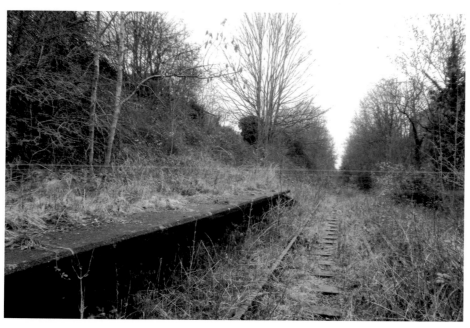

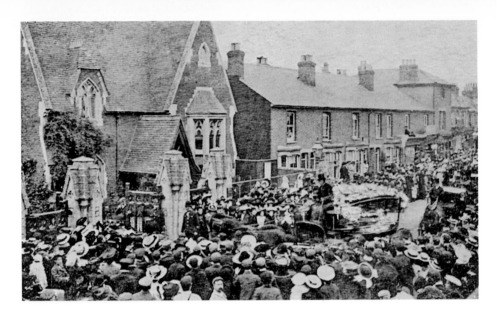

Vicarage Road Cemetery

One of the most bizarre pictures to be taken and used as a postcard was the funeral of a twenty-one-year-old Watford-born girl, Mary Sophia Money. The mysterious circumstances surrounding her untimely and tragic death were sufficient to attract a considerable crowd of mourners at the Vicarage Road cemetery on 3 October 1905. Mary's mutilated body had been discovered in Merstham railway tunnel on the London to South Coast line during the late evening of Sunday, 24 September. The two most likely trains on which she could have travelled had both emerged from the tunnel with all their carriage doors closed. Was it suicide, an accident or as appears most likely, murder, as somebody must have closed the carriage door after Mary had fallen to her violent death? An interesting hypothesis. With the Victorian frontage now disappeared from this quiet graveyard, not many visitors are aware of the drama, the local media dubbed 'The Tunnel Mystery' that ended here over one hundred years ago.

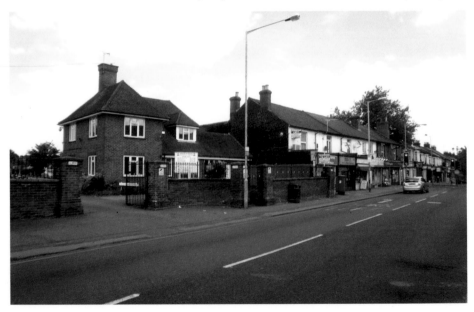

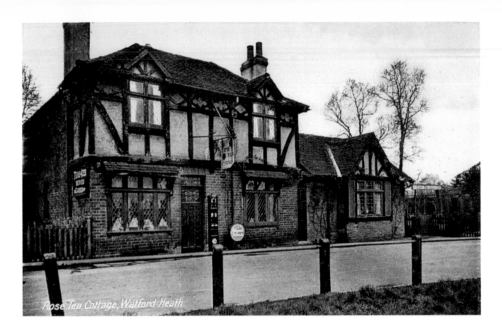

Rose Tea Cottage, Watford Heath

Rose House

Originally called Rose Tea Cottage, this charming locally listed building in Watford Heath was formerly a tearoom with a lovely well-stocked garden to the rear containing ornate trelliswork and a pretty gazebo. The property was constructed in the mid-nineteenth century and may have been part of the Oxhey Grange Estates' development of Watford Heath. An amusing anecdote at the time was that the owner of Oxhey Grange Developments, a devout Quaker, used the Rose Tea Gardens in an attempt to encourage the local workforce away from the nearby public houses. One can only speculate on how much success he had! Sadly, the tearoom and gardens are no more with the property now under private ownership.

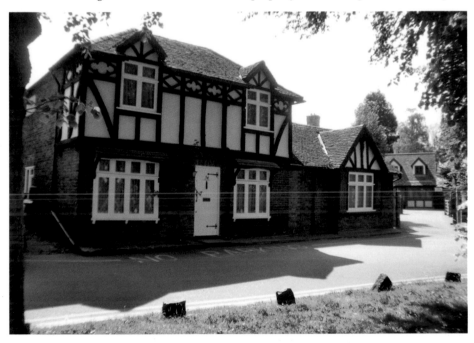

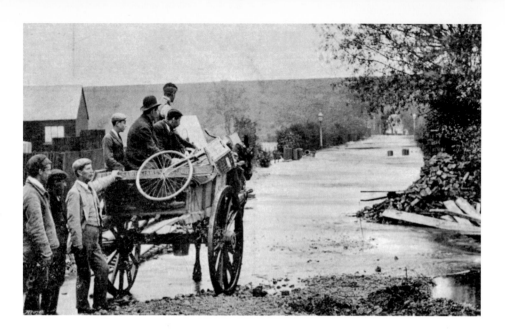

Bushey Hall Road

Following the floods of 16 June 1903, the free ferry supplied by the Urban Council looks as though the service was certainly a welcome relief for both the cyclist and pedestrians alike. The pony and trap would convey the passengers past the row of cottages on the right, hidden behind the large tree on the corner of what is now Greatham Road, through the narrow tunnel of the railway bridge to the appropriately named Water Lane on the other side. Here, they would alight to then make their way to the High Street and beyond.

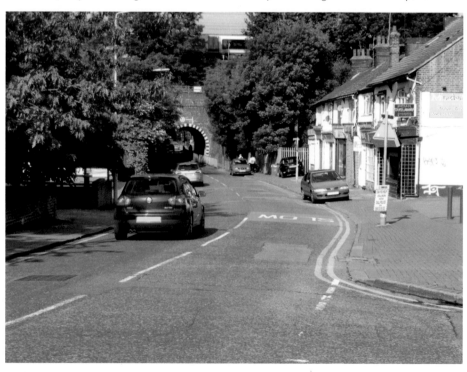

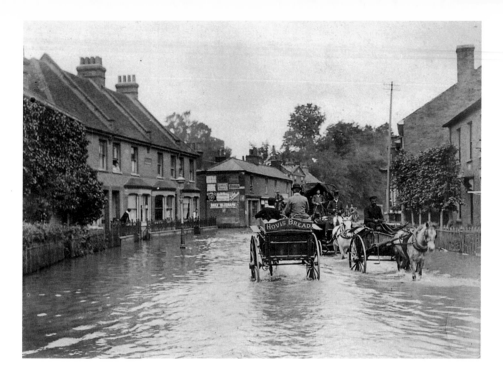

Floods in Lower High Street

Despite the severe floods of 16 June 1903 and the obvious difficulties encountered around Watford, some traffic was managing to negotiate the affected areas, including a baker's cart making his deliveries and a gentleman in a carriage with his liveried driver. Although considerable change has taken place in the intervening years, the row of cottages on the left still exists in this part of Lower High Street near Bushey Arches, with a small café now occupying the site where the little shop advertising the *Daily Telegraph* used to be.

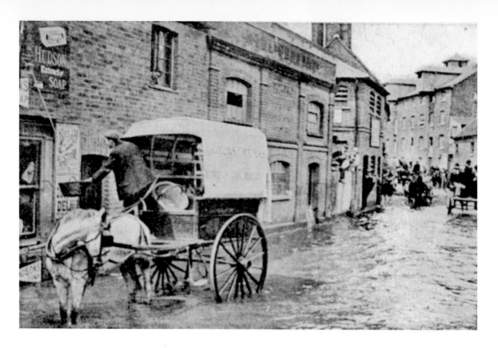

Business as Usual!

The photographers of the day were indeed kept busy on Tuesday 16 June 1903 covering the floods that had devastated various parts of Watford – no mean feat under these abnormal conditions when one considers that they had to trundle around their heavy equipment, including possibly the new Sanderson plate camera and tripod. The enterprising delivery man above appears to have solved the problem of loading and unloading his cart before departing on his rounds. Today, following a steady programme of redevelopment over the years, the area is completely unrecognisable to what it used to be over a century ago, as can be seen in this picture taken on a bright February day in 2011, just down from Local Board Road in Lower High Street.

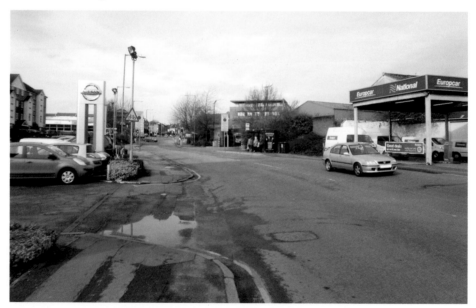

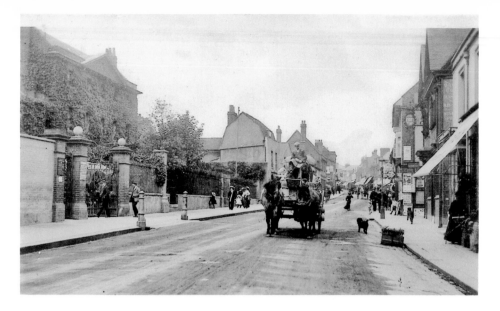

Lower High Street

With the First World War barely one year old, this real photo card of the High Street was posted on 3 September 1915 from a lady staying in Nascot Wood who remarked to the recipient, her aunt, in London, that 'it is very quiet here, I will be glad to get back to Town again'. Ninety-six years later with considerable change due to redevelopment and road widening, the area is still quiet, although this can be attributed to a majority of the traffic now being diverted to the ring road, constructed in the early 1970s. The large building on the left of the picture is the Benskin's Brewery mansion, now Watford's prestigious museum.

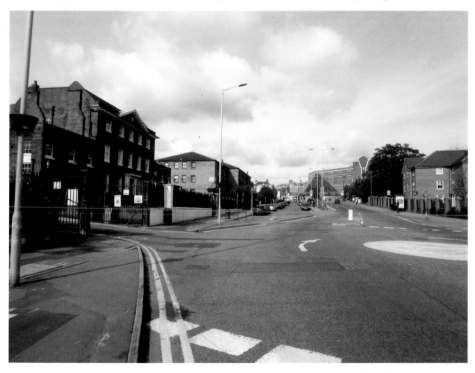

Benskin's Brewery

This distinctive Grade II listed building, built by Edward Dawson in 1785, was once owned by John Dyson – a brewer who had originally founded the Cannon Brewery in the High Street. In 1867, the business passed to the Benskin family who lived in the house, the brewery being at the rear. With a successful takeover bid from Ind Coope in 1957 and further mergers during the intervening years, brewing continued in Watford until production ceased in the early 1970s. The site was subsequently demolished and redeveloped in 1979, with the fine Georgian mansion now home to Watford Museum. (Top picture courtesy of Watford Central Library).

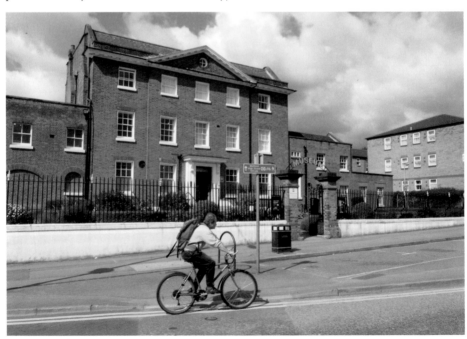

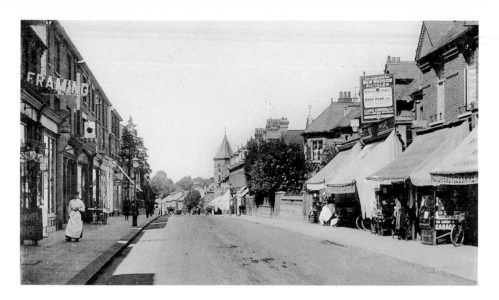

Queen's Road

Once a bustling thoroughfare leading from the High Street, Queen's Road – built in the 1860s and named after Queen Victoria – had its fortunes dramatically altered when work commenced on the large Harlequin Shopping Centre site in the late 1980s. Although most of the old shops from the High Street to Derby Road have now gone, it is gratifying to note that Lloyd, Cooper & Co. advertising new Hudson bicycles at No. 61, still remain after over 100 years of trading on the same premises. Today it can be deemed as the oldest motor cycle dealer in the UK. Interestingly, while shop fronts along the road have gradually altered over the years, there is little architectural change to the façade of the first floor and above. The drapery and furnishing emporium of Messrs Trewin Bros at Nos. 20/30, which has long been part of the John Lewis Partnership, is now, as John Lewis, one of the major retail outlets in the Harlequin.

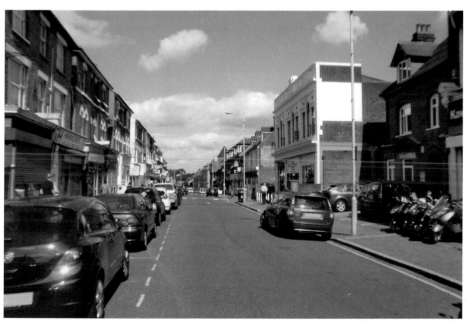

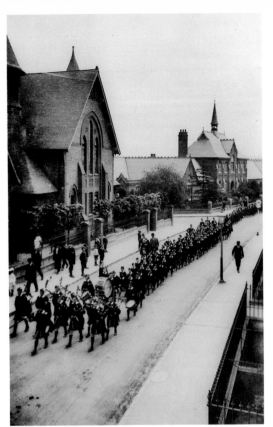

Derby Road Baptist Church and Royal Caledonian School

One can almost hear the stirring sounds of the pipes and drums as the Royal Caledonian School, seen in this early photograph, march past the Derby Road Baptist church on the left of the picture, leading a procession of scholars and teachers to Sunday worship in Watford from their school in Aldenham Road, Bushey. With their versatility and professionalism, the 'Caley Pipes and Drums' as they were called, regularly attended church parades and local ceremonies for a great many years, including Armistice Day commemorations at the Bushey war memorial. In 1996, the school premises were purchased by the Purcell school, one of the foremost schools of music in the UK. The proceeds of sale were used to set up the Royal Caledonian Schools Trust. The Baptist Tabernacle was opened on 4 January 1888, although it was twenty years earlier that a small band of devoted men and women formed the church that now worships at Derby Road.

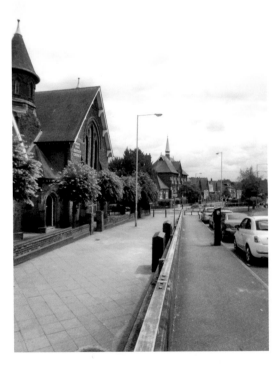

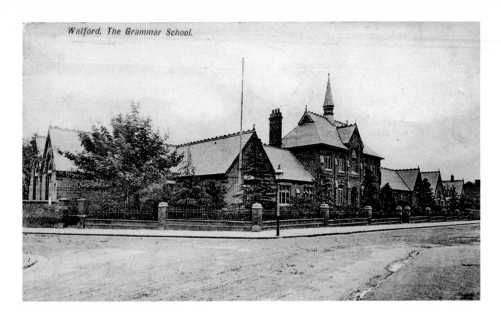

Watford, The Grammar School.

The Grammar School

Originally called the Watford Endowed Schools, the buildings for the boys' school in Derby Road were opened by the Earl of Clarendon on Monday 21 April 1884, with those for the adjoining girls' school opening the following day. The initial intake was sixty-nine boys and forty-six girls. By the turn of the century, with both schools now far too small to cater for the number of pupils in attendance, new premises were constructed for the girls in 1907 at a site in Lady's Close. Five years later, it was the boys' turn when they moved into a modern and spacious development in Shepherd's Road. The old Derby Road buildings are now the Central Primary School & Nursery.

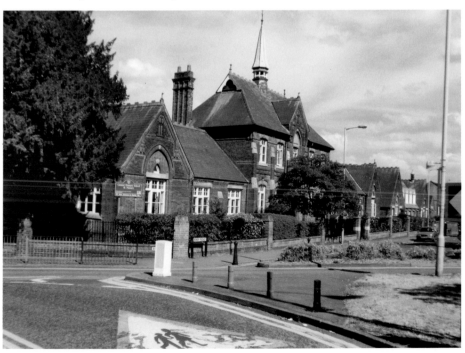

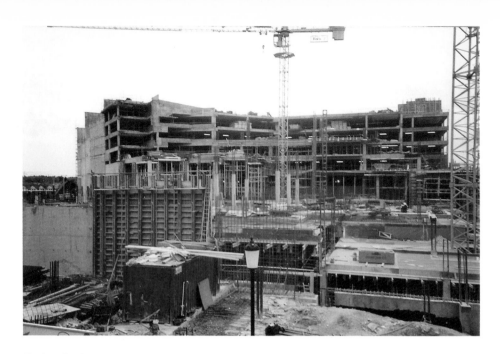

Harlequin Centre

Like the metaphoric rising of the phoenix from the ashes, so the exciting new Watford Harlequin Centre starts to take shape. Originally known as the Mars 1 project, the name Harlequin Centre was chosen by a panel of judges after more than 250 people participated in a competition to name the shopping complex. With demolition and ground clearance work commencing in the autumn of 1988, many private houses and retail premises, together with Clifford Street, Carey Place, Charles Street and Albert Street, disappeared as the bulldozers set to work on the 12-acre site. Completed in 1992 and costing in excess of £100 million, the Centre has over 140 retail outlets and cafés and is a popular venue for both local people and those from further afield. (Top picture courtesy of Cynthia & John Morgan).

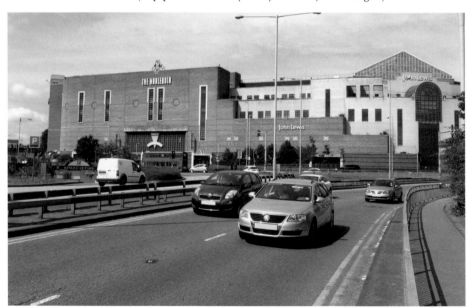

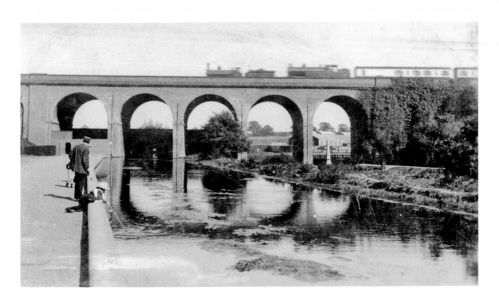

Five Arches Railway Viaduct

This delightful card, posted on 11 September 1913, shows the Five Arches railway viaduct, which was constructed over the River Colne in the mid-1830s to accommodate the London & Birmingham Railway opened in 1837. The obelisk in front of the fifth arch above was originally erected by the Corporation of London to mark the boundary where the payment of a 1s 1d duty per ton was levied on all coal being brought into London south of the marker. This practice continued until 1890. The obelisk was moved to the opposite side of the river in 1984. Nine years later, a new dual carriageway – Stephenson Way – was constructed through two of the arches as a direct link from the M1 motorway to Watford town centre.

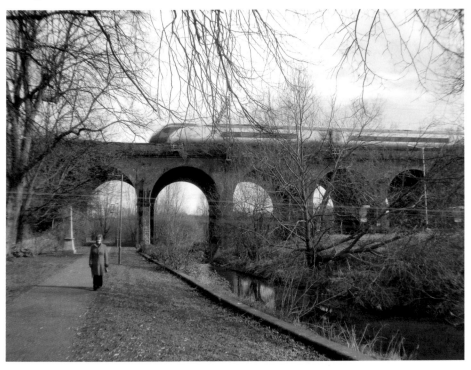

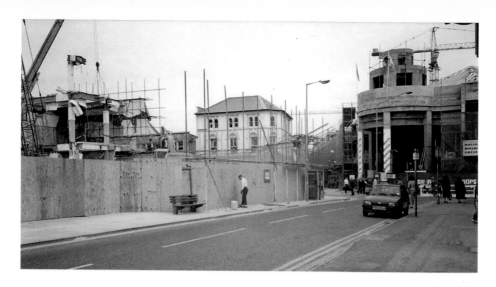

King Street

A comparatively recent image of Watford's changing face as seen in this April 1990 photograph taken from King Street. This shows the construction of the main entrance to the Harlequin Shopping Centre in the High Street and the back of the new Woolworth site, now occupied by McDonald's. With redevelopment continuing along Queen's Road opposite, it won't be long before the large, distinctive building, the old Westminster Bank in the background, is reduced to rubble as well. As with many other parts of the town, King Street has seen massive change; it once extended as far as Lady's Close where the girls' grammar school is situated, before the introduction of the one-way system that bisected the road just past Watford Place. From 1889 until 1940, a police station occupied the site on the corner of Smith Street, but in 1961 a new public house, the aptly named Robert Peel (since closed), opened its doors on the same location where once drunks and vagabonds had been held in custody. A somewhat bizarre change of circumstances! (Top picture courtesy of Cynthia & John Morgan).

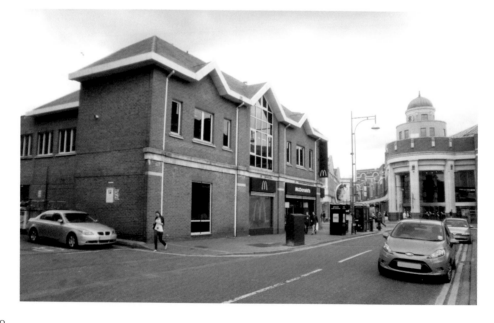

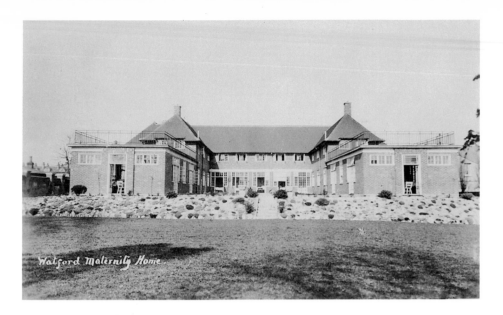

Maternity Home

Watford Maternity Home, straddling what is now the ring road, was opened at 21 King Street in 1935 and rebuilt in 1937 by the County Council who had taken over the management of the building from the County Nursing Home Association. Following a brief period as the Maternity Wing of the newly formed Watford General Hospital, it eventually closed in 1969 when a new maternity unit opened at the hospital in Vicarage Road. The home was demolished as part of a road-widening scheme with new housing in King's Close now occupying part of the old site.

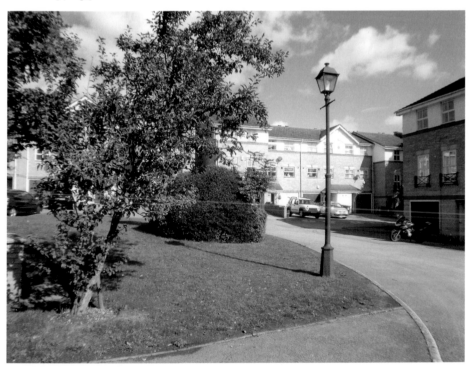

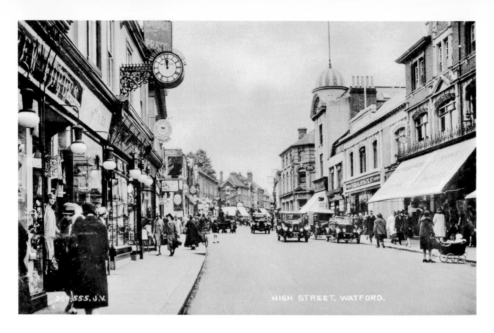

High Street – Junction with King Street and Queen's Road

Frozen in time at midday, this lovely old 1920s photograph was taken just down from the junction with King Street and Queen's Road, and shows the High Street looking north. The delightful shop frontages include the reputable premises of Benjamin Morse, the high-class jeweller and watchmaker, situated next door to the motoring business of Messrs Tucker Brothers, an authorised dealer for Morris Cars. On the opposite side of the road can be seen the well-known bazaar of Marks & Spencer, adjacent to Sketchley Dye Works and Boots on the corner of Queen's Road. This truly superb image captures a slower and more genteel way of life in the early part of the twentieth century.

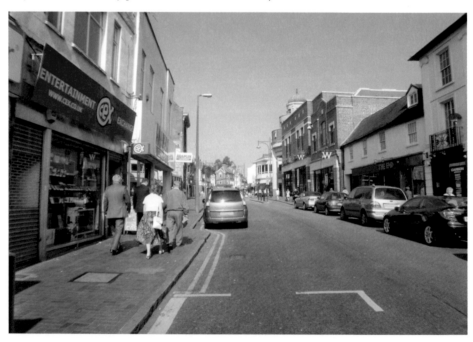

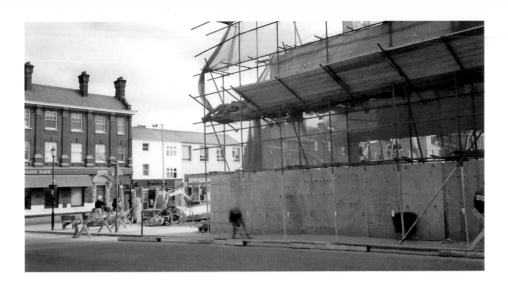

Corner of King Street

With the continuing development of Watford in the early 1990s, the above picture shows the construction of the building that would eventually become a modern Woolworth store. Following Woolworth's subsequent move several years later to a new site near Market Street, the premises are now occupied by a McDonald's fast food outlet. The entrance to King Street was formerly the private carriageway to Watford Place – now a firm of solicitors – and once the home of Dame Elizabeth Fuller, the founder of the Free School in 1704. The lodge to Watford Place, which stood on the right-hand corner plot, was later opened as the King's Arms public house in 1852, where it remained until 1961 and its subsequent demolition. The large building depicted on the left is Barclays Bank, now demolished apart from the external façade to the front and side elevations. The site to the rear of the old bank is currently a temporary car park pending redevelopment. (Top picture courtesy of Cynthia & John Morgan).

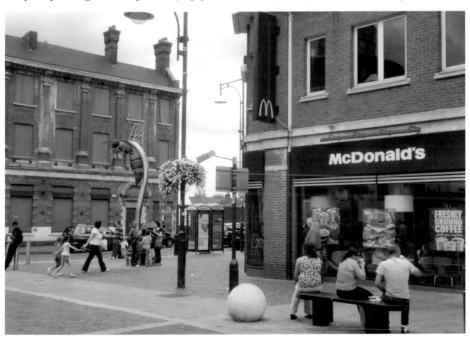

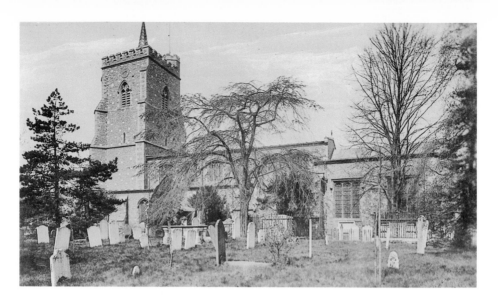

St Mary's Parish Church

The beautiful Church of St Mary, one of the largest churches in Hertfordshire, was built *c.* 1230 in the centre of Watford, although the imposing bell tower was added during the fifteenth century. To the left of the chancel is a small chapel where members of the Essex family are buried. Two of the exquisitely carved monuments are testament to the sculptural skills of Nicholas Stone, a noted seventeenth-century sculptor and architect. The fine flint and stone dressing to the exterior of the church was carried out during the restoration of 1871. One of the tombs in the churchyard is that of George Edward Doney, a black slave and a native of Virginia, who was a servant to the fifth Earl of Essex for over forty years, and was buried in 1809.

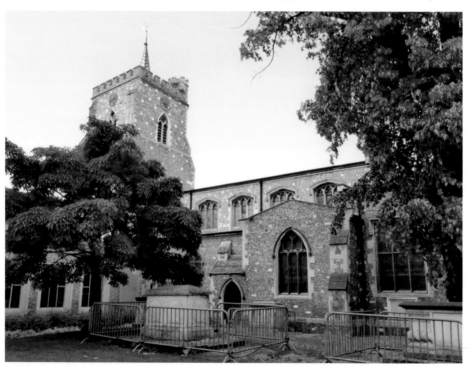

New Street

This picture of a squalid, rundown area of Watford, taken *c.* 1914, depicts New Street, a narrow road that ran from the Market Place to Church Street. The courtyard entrance to Ballard's Buildings can be seen on the right of the image, where a motley assortment of residents lived, including a rat catcher who no doubt made a reasonable living from his somewhat unenviable trade. Originally intended as temporary dwellings to accommodate a large number of railway workers in the 1830s, the poor housing lasted for almost a hundred years until they were cleared under a slum clearance order in 1926. Today, where once the unsavoury and dilapidated buildings used to be, a multi-storey car park now stands, dominated by the imposing structure of St Mary's parish church, as taxi cabs patiently await their next fare.

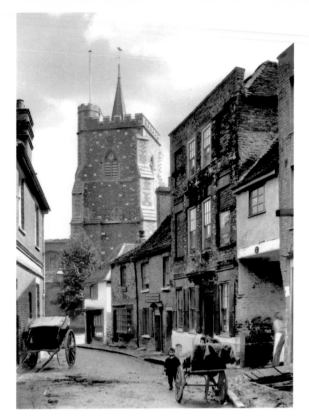

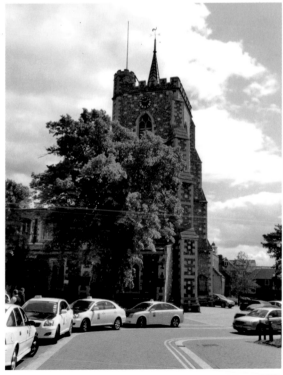

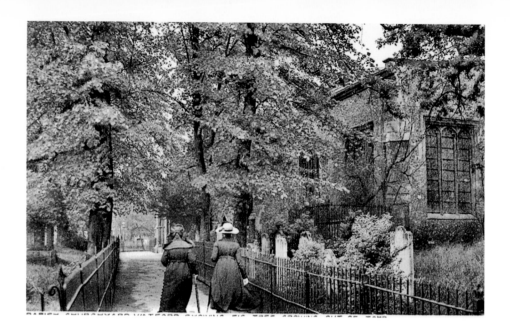

The Fig Tree Tomb

One of Watford's strangest legends is that of the Fig Tree Tomb in St Mary's churchyard. The myth goes that a lady who was an atheist was buried in a vault close to the wall of the church. On her deathbed she is reported to have expressed a wish that if there was a god a fig tree might grow from her heart. Whatever the story, a fig tree did indeed grow from the tomb and remained there until it died in the severe winter of 1962/63. The fig tree can just be seen to the left of the large window on the right-hand side of the early 1900s picture above. However, another version of the legend states that the unbeliever was a man, one Ben Wangford, who lived in the mid-1800s and was also buried in the churchyard. The tomb remains, although the inscription is unreadable due to erosion, which may account for some of the mystery surrounding this intriguing tale.

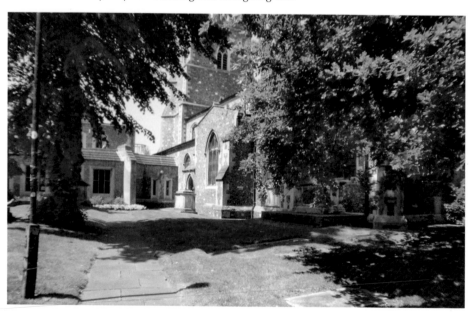

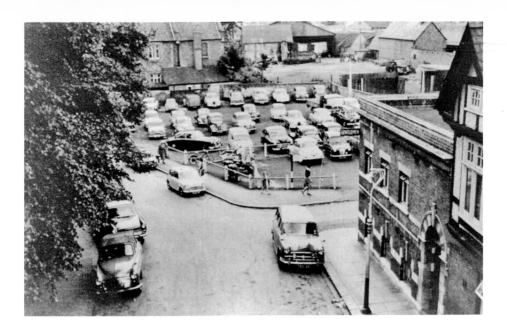

St Mary's Square

A multi-storey car park now occupies the temporary parking area, seen above in Church Street, where once stood St Mary's National School and the old workhouse built by the parish in 1721. Next to the car park is the site that used to be occupied by the notorious Ballard's Buildings, an overcrowded slum just off New Street, since demolished. The One Bell public house is just visible on the right. Today, this revitalised part of the High Street in front of St Mary's church and the One Bell is a popular venue to sit and relax over a quiet drink or a coffee in a pleasant piazza-type environment, a far cry from when Watford's weekly livestock market took place at this location over one hundred years ago.

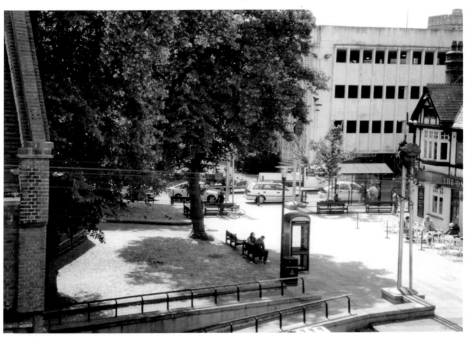

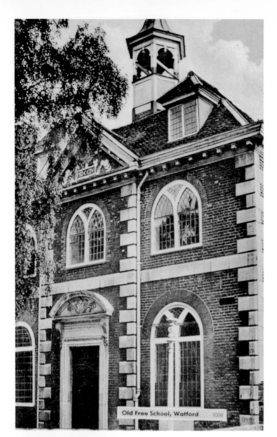

Old Free School, Watford 1008

The Free School

Built in 1704, the Free School was founded by Elizabeth Fuller as a charity 'for the teaching of forty poor boys and fourteen poor girls of Watford in good literature and manners'. With the aid of endowments and bequests, the institution survived for almost 180 years when charity schools as such ceased to function. Following its closure in 1882, the establishment was transferred to a new building in Derby Road called the Endowed School, the precursor of the Watford Grammar Schools for Boys and Girls. This elegant Grade II listed Queen Anne building is now privately owned by Recovery In-Sight Social Enterprise (R.I.S.E.), a charity providing advice, training and well-being for people affected by mental health difficulties.

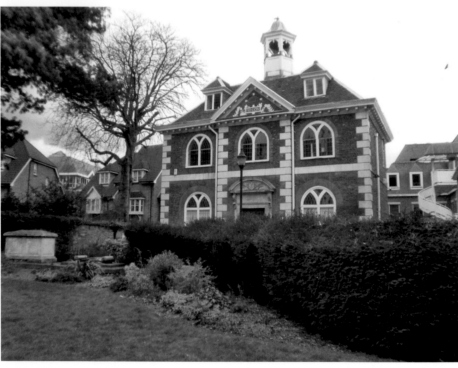

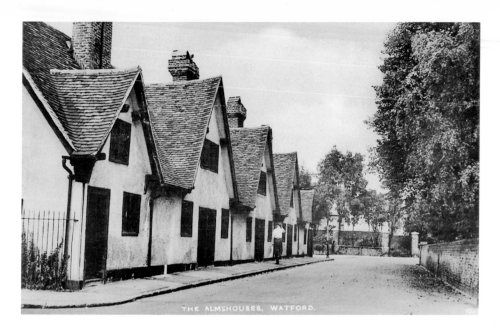

THE ALMSHOUSES, WATFORD.

Essex Almshouses

These beautifully preserved Grade II listed almshouses in Church Street were built in 1580 by Francis Russell, the second Duke of Bedford, so that 'eight poor women might inhabit and be maintained in the said eight almshouses'. Due to their dilapidated condition in the early 1930s, a successful appeal was made to preserve the buildings, which today remain the oldest inhabited dwellings in Watford. For safety reasons, access to the almshouses is now from the gardens to the rear, with the front doors onto Church Street being permanently closed as 'false' doors.

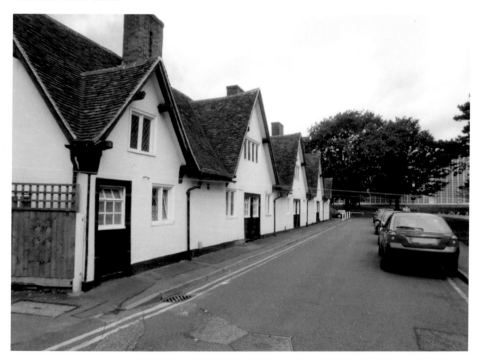

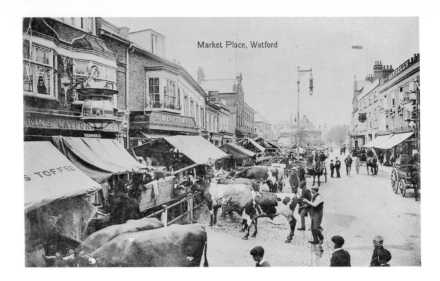

Market Place, Watford

Market Day

Another busy Tuesday in the High Street is depicted in this *c.* 1910 image as the weekly livestock market gets under way, a market that was granted by Charter in the reign of King Henry I (1100–1135). Although attracting farmers and traders alike from miles around, the High Street was a smelly and noisy place through which to venture, and for many the general merchandise market held on a Saturday must have been far more appealing. Trading remained in the High Street until 1928 when stallholders were transferred to a new site in Red Lion Yard, whilst the cattle market transferred to Stones Alley, just behind the post office in Market Street, where it remained until its ultimate closure in the last week of December 1959. To the right of the picture above the premises of the well-known drapers and furnishing store, Cawdells, can just be seen, since demolished as part of the Central Car Park redevelopment scheme in the mid-1970s, the location that now forms the entrance to Charter Place Shopping Centre.

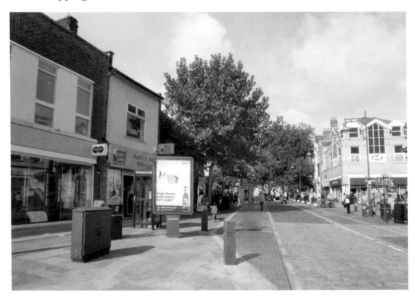

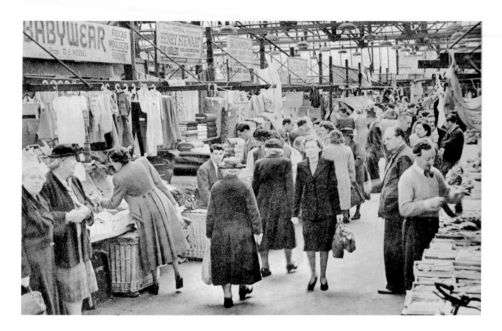

The Market

Following the market's move from the High Street to Red Lion Yard in 1928, trading was initially carried out in the open, although it was eventually covered over four years later. In the mid-1970s, the bustling Corporation Market – seen above in 1950 – transferred to its present location in Charter Place where, on a Tuesday, Friday and Saturday, a variety of high-class goods and services are on offer to the stallholders' many loyal customers. During the drab, austere, post-war years following the cessation of hostilities in 1945, rationing was still very much in evidence, although with clothes being de-rationed in 1949 there appears to be quite a keen interest in the stall selling babywear, frocks, woolsets and socks. Youngsters would have to wait another three years before sweets were off ration, with the stringent controls that had been instigated in 1940 finally ending in 1954. (Top picture courtesy of Watford Central Library).

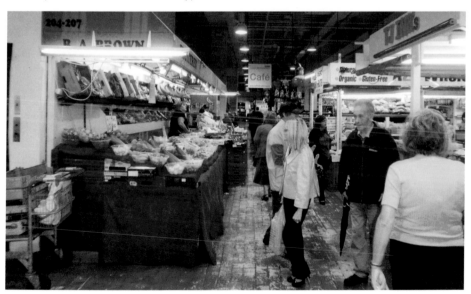

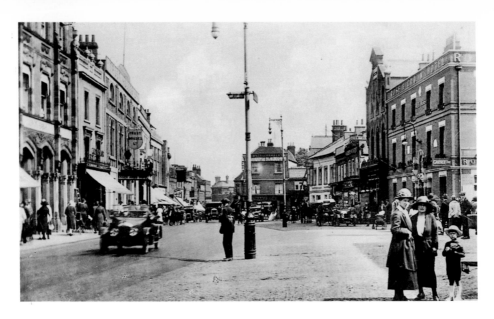

Market Place – Junction with Market Street

With the Rose and Crown Hotel on the right of this delightful 1920s photograph, and Lloyd's Bank and the Essex Arms – part of Trust Houses Ltd – on the left, the picture shows Market Place now devoid of stallholders and livestock following the moves of 1928. Much like today, drivers were quick to seize the opportunity for a ready parking space, and the area where only a short time previously cattle, pigs and sheep had been sold was no exception. The Essex Arms Hotel survived until the building was demolished in 1931, when a branch of the chemists, Timothy Whites, and an extension to the adjoining Cawdell's drapery store was added. The modern-day view was taken in the summer of 2010.

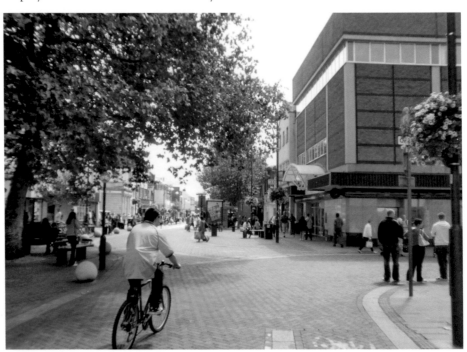

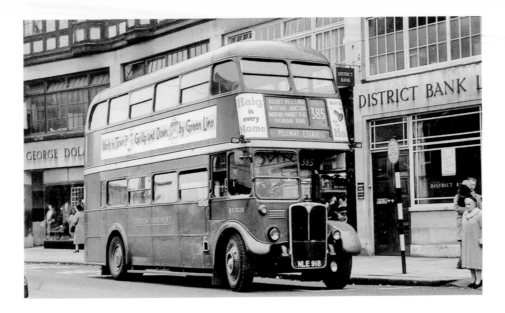

Public Transport in the High Street

Seen here in the 1950s is London Transport's double-decker bus RT 3028 travelling past the District Bank (now Barclays) in the High Street in the good old days before traffic restrictions and pedestrianisation were introduced. Interestingly, the bus had a chequered history as, following its private purchase from LT in 1979 for preservation purposes, it was unfortunately allowed to deteriorate on a farm for many years until it was eventually sold and fully restored. In 1999, it was used to publicise the West End musical *Summer Holiday* before slipping quietly back into retirement. With the introduction of the ring road in 1972, the majority of Watford's traffic was diverted from the High Street, although many of the town's bus routes now start and terminate in this area. The mock-Tudor building in the background was built on the site of the Compasses public house.

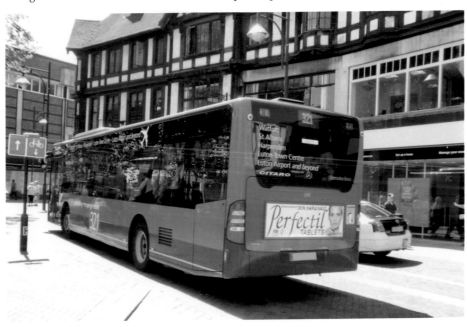

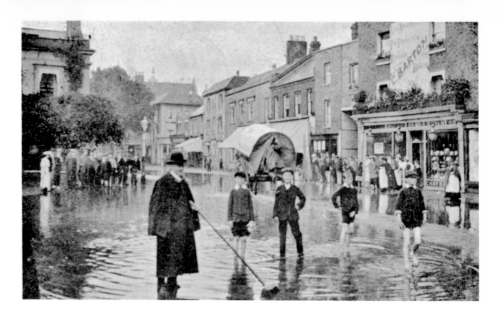

Waterlogged Watford!

Another flooded area after what was called the 'Great Storm of 27 July 1906' was the Market Place, where the appearance of a photographer, as was usual in those days, attracted a great deal of inquisitive attention. With the youngsters wearing their thick all-year-round clothing and the obligatory headgear, the rainfall must have been a welcome opportunity to cool off, especially as the schools had no doubt broken up for the summer holidays by then. The elderly gentleman in the Homburg hat and Ulster coat and cape, possibly the owner of one of the retail premises nearby, appears to be posing with his broom for the photographer, as it is doubtful that any real effort to clear the water was involved. With a large group of onlookers standing outside Charles Barton's bakery opposite, it looks as though they and the other shops adjacent to Meeting Alley may not have been quite so affected by the downpour as many of the other establishments in the vicinity.

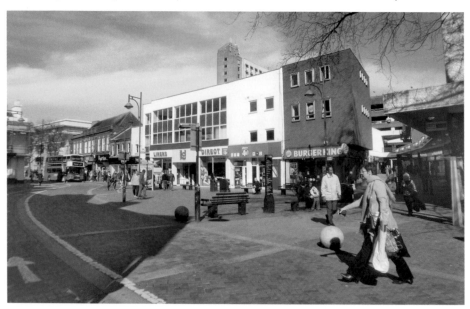

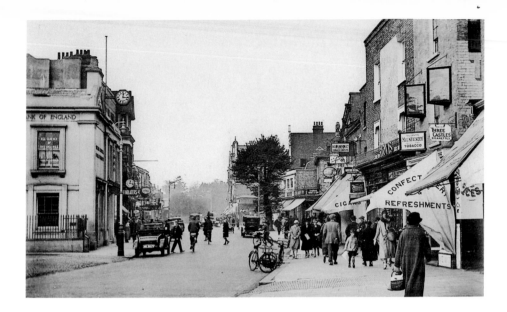

High Street looking North (1)

This charming 1920s image shows the High Street as it approaches the junction with Clarendon Road on the far right, with the façade of Clements' drapery and furnishing emporium just visible in the distance. The National Provincial Bank is the large building on the left, now a vibrant café bar, the Que Pasa. These were the halcyon days when the few people who could afford to run a car were able to park anywhere in the town without the modern-day encumbrance of yellow lines and parking restrictions. No fear either of theft or vandalism to the bicycles left unattended at the kerbside. They would still be there safe and sound on their owners' return.

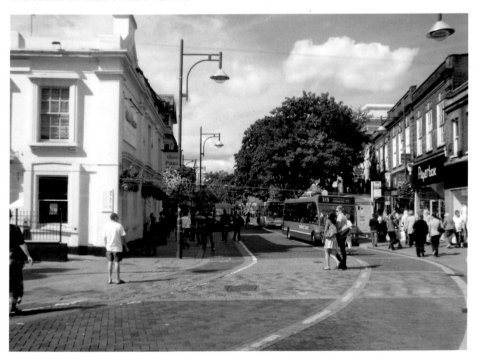

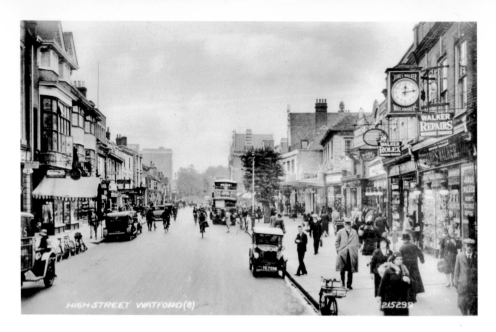

High Street looking North (2)

Another nostalgic glimpse of the town centre of over eighty years ago, where the pavements are filled with busy shoppers thronging the well-known High Street shops such as Saxone Shoes, W. H. Smith & Son and James Walker the jewellers, where, amongst other exquisite items on offer, a Rolex precision watch could be purchased and repairs undertaken at moderate charges. With the fascinating detail depicted in the above image of an age long since passed, much of the charm and atmosphere from those bygone days has sadly been lost forever, as seen in the same view today. This is due in no small part to two major changes in Watford: the ring road and the Harlequin Centre, where many of the larger shops and stores now trade.

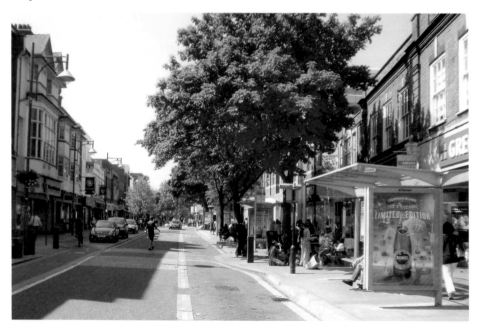

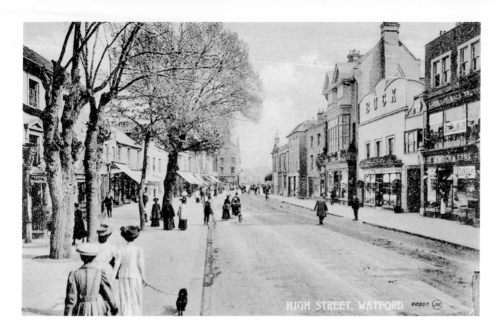

High Street Looking South

The long-established premises of W. Wren & Sons can be seen on the right in this early postcard of the High Street looking from Clarendon Road towards the Market Place. Wren's, seen here advertising saddlery, bags and trunks, later sold quality sports and leather goods before eventually moving to new premises in Upton Road where they stayed until the 1960s. Next to Wren's is the popular local restaurant and caterers of Bucks, founded in 1868 by Mr and Mrs Philip Buck. The firm remained in the High Street until 1961 when they transferred to a new building in Exchange Road, where their fortunes gradually dwindled until, finally, demolition in preparation for the new ring road system brought four generations of one of Watford's oldest businesses to a close.

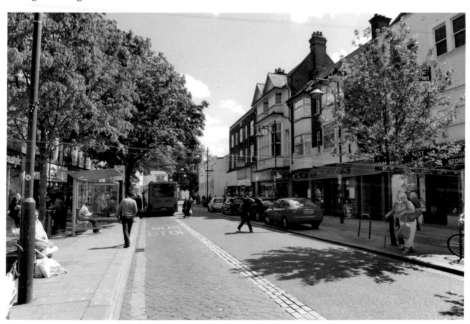

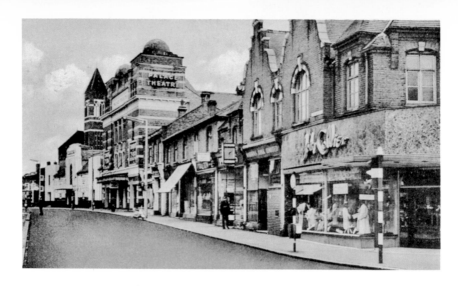

Palace Theatre

Situated a few yards from the High Street, in Clarendon Road, is arguably one of the country's finest theatres – the Watford Palace. This lovely Edwardian structure opened on Monday, 14 December 1908 with a 'High Class Vaudeville Company' and has continued to provide outstanding entertainment to the community and beyond for over one hundred years. The actors and actresses who have 'trodden the boards' are literally a 'Who's Who' of show business, ranging from celebrities such as George Robey, Gracie Fields, 'Our Gracie', and Jack Hylton and his Band, to local boy Terry Scott, the comedian, and Anthony Booth, the father of Cherie Blair, wife of the former Prime Minister. This postcard from the late 1950s also shows John Collier 'the window to watch' men's outfitters, previously the Fifty Shilling Tailors, on the corner site now occupied by the Halifax.

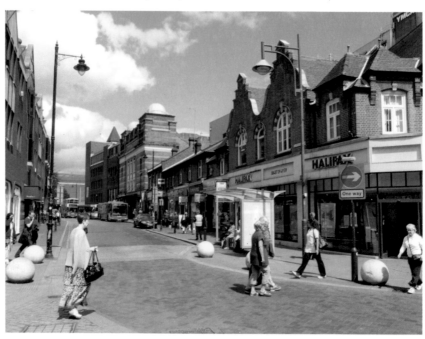

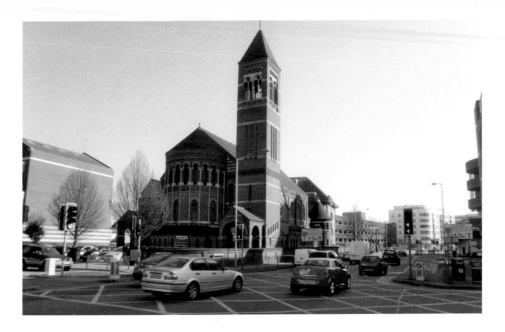

Beechen Grove Baptist Church and Clarendon Hall

Standing majestically on the corner of Beechen Grove and Clarendon Road is the Beechen Grove Baptist church, a fine example of Victorian architecture dating back to 1877. An earlier Meeting House, near where Charter Place is today, had been built for worship in 1721 following the commencement of nonconformity in Watford fourteen years earlier. The car drivers streaming past the church and along the ring road are probably completely unaware that on the site of this busy junction once stood the old Clarendon Hall, later the Territorial Drill Hall, where magic-lantern lectures were given or political meetings – such as those for the Liberals as depicted in the postcard of January 1906 – were held. The inset picture (*below*), taken in March 1929, shows a parade of civic dignitaries and members of the British Legion marching from the Hall to St Mary's parish church for a Service of Dedication, following the presentation of the Legion's Standard by the Earl of Clarendon. (Inset picture courtesy of Watford Central Library).

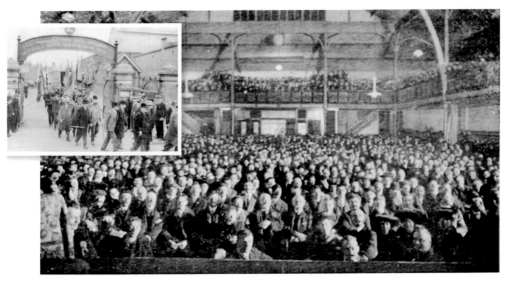

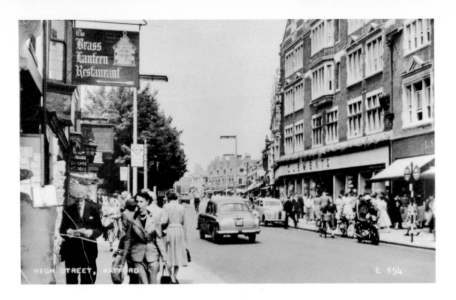

The Parade

With the imposing building of Clements' Department Store on the right, this photograph dating back to the 1950s shows the Parade, just north of Clarendon Road, busy with shoppers in those days well before the development of the ring road and the flyover as seen in the 2011 picture. Trading on the same site for over 100 years, Clements finally closed its doors in 2004 when the chain of T. J. Hughes' stores took over the premises. On the opposite side of the road, and occupying a fifteenth-century timbered building, is the highly respected business of Jackson Jewellers, a long-established local firm who moved into the Parade location in 1954. The Brass Lantern too, like so many similar tearooms and small restaurants from those bygone days, has long since disappeared. The area where light lunches and dinners were once served is now occupied by an employment agency.

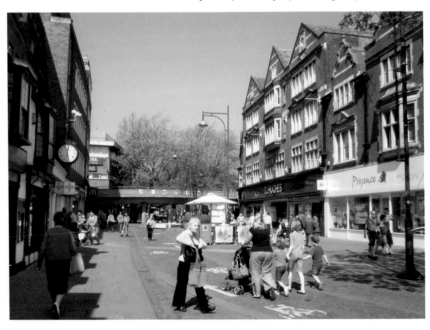

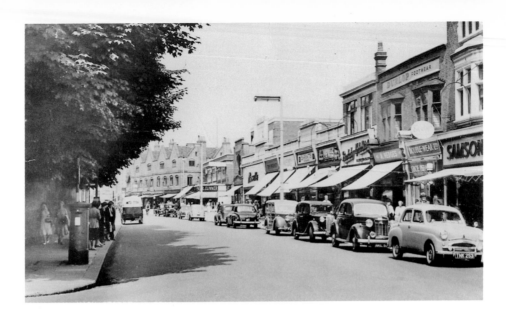

The Parade from Upton Road

How times have changed! Pedestrianisation has now replaced the flow of traffic along the Parade where once people queued for their buses home. With the seventeenth-century Monmouth House in the background, many readers will remember shops such as R. Gunner the butcher's, Moselle's, where the latest gowns and fashions were on display, and the Regency Restaurant. To the right of the picture can be seen the bootmakers of A. Hedges & Sons, whilst next door, the premises of Double Wear Ltd advertise that shoe repairs are undertaken – a useful coincidence. It was during the early 1970s that this part of Upton Road, on the left, formed the flyover within the new ring-road system. The modern-day comparison below has been taken just north of the flyover.

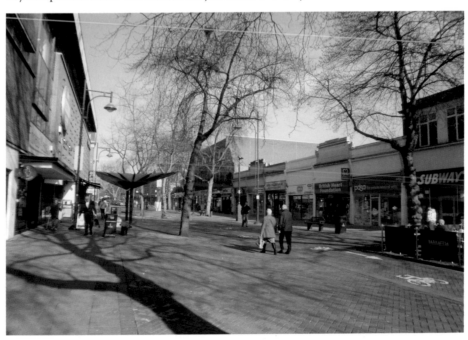

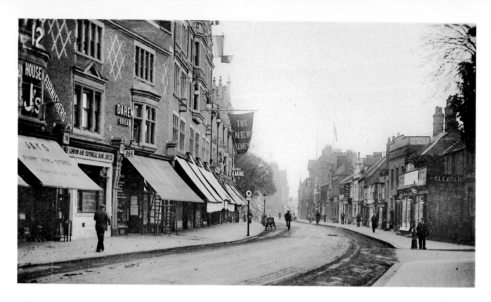

The Parade Looking Towards Clarendon Road

The full effect of the major road changes can be seen in the 2011 photograph below, when compared with the older image, as the flyover bisects the Parade into two. The coats of arms of Watford's Twin Towns – Mainz, Nanterre, Novgorod, Wilmington and Pesaro – are displayed on the side of the flyover, with T. J. Hughes' spacious store occupying the premises where previously Clements had traded since 1898. It is worthy of mention that this lovely building with its distinctive façade was constructed on the site once occupied by Watford House, a large mansion where the celebrated local philanthropist, Dr Alfred Brett MD had spent a great many years of his life. Watford House, built *c*. 1775, was where the county historian, Robert Clutterbuck (1772–1831) lived, publishing his first volume of the *History of Hertfordshire* in 1815, the same year that the Battle of Waterloo took place.

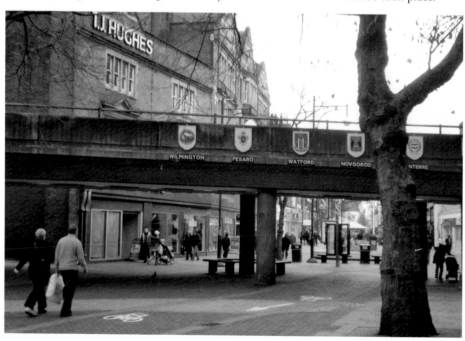

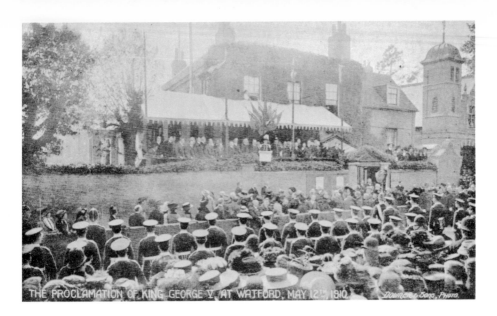

THE PROCLAMATION OF KING GEORGE V AT WATFORD, MAY 12TH 1910.

Proclamation of King George V

Just over nine years after the announcement that Edward VII had succeeded to the throne following the death of Queen Victoria, so Watford witnessed yet again the proclamation of a new monarch. Following Edward's death on 6 May 1910, crowds had gathered six days later at Upton House in the High Street, the centre of local government, to hear the news that George V was now their King. Before Watford's Charter in 1922 and its incorporation as a borough, the council offices had previously been in Local Board Road before moving to larger premises at Upton House in 1892. The fire station next door can be seen to the right of the picture. Both buildings were demolished in the early 1960s, with Gade House now occupying the site.

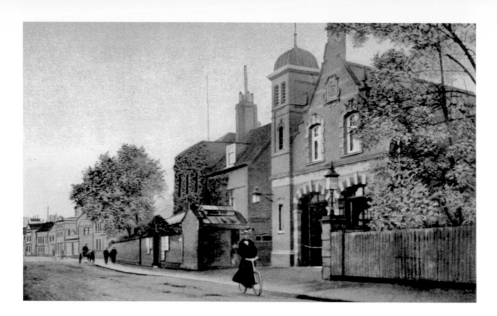

Fire Station

In the summer of 1900, the new Watford fire station with its unique frontage was opened next to the Urban District Council offices in the High Street, where Gade House is now situated. To celebrate the occasion, an informal celebratory dinner was held on the premises for forty people, which included members of the Town Brigade, Croxley Mills Brigade and the Sedgwick Brigade, the latter having been formed in 1876 when Mr F. Sedgwick obtained a horse-drawn Shand & Mason steam-operated fire engine, popularly known as a 'steamer', for his brewery. Although the Sedgwick Brewery Brigade was an independent fire service, they very often assisted the Town Brigade at major fires. This included Watford's largest conflagration, when the Vi-Cocoa factory at Callowland was gutted in February 1903, attracting a huge crowd of spectators from far and wide. The fire station remained in the High Street until 1961, when they moved to their newly built £80,000 premises at the junction of Rickmansworth and Whippendell Roads, operating from there for a further forty-eight years until a new £5 million state-of-the-art station (*below*) opened in Lower High Street on 19 November 2009, on the exact location where Sedgwick's Brewery had been all those years before. (Bottom picture courtesy of Roger Middleton, Curator, Hertfordshire Fire Museum).

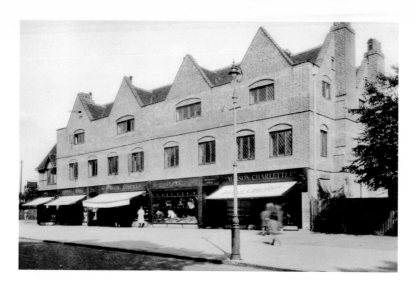

Monmouth House

What do the Cookery Nook, Zinco's and Queen Elizabeth I all have in common? The answer: Monmouth House. Situated at the northern end of the High Street and originally called the 'Mansion House', this early-seventeenth-century Grade II listed building was constructed by Sir Robert Carey, the first Earl of Monmouth, who in 1603 took the news of Queen Elizabeth's death to her successor, King James I. Following Robert's own death, the house was occupied as a Dower House by his widow Elizabeth until her demise in 1641. In 1771, the accommodation was divided in two and altered in 1830, the north part being called Monmouth House and the south The Platts. During the late 1920s, the building was converted to business premises and retail outlets retaining the name of Monmouth House. In the 1950s, a popular venue there was Cookery Nook, a quintessentially English tearoom with a Tudor beam ceiling, where delicious scones and light lunches were on offer, whilst the superior Italian ristorante, Zinco's, is today one of Watford's top dining venues. (Top picture courtesy of Watford Central Library).

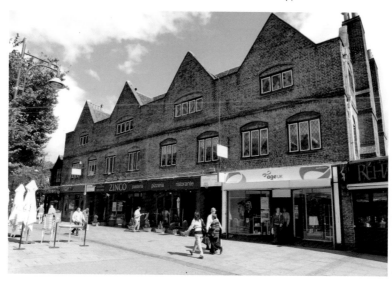

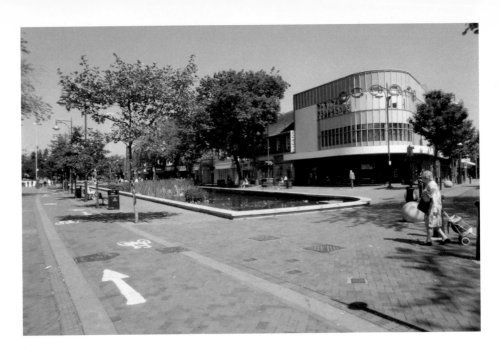

The Pond Area

Popularly known today as the 'Café Quarter' on account of the many bars and clubs in the area, this vibrant Mecca surrounding Watford's historic pond attracts thousands of fun-seeking young people each week. Reigning supreme over this pulsating nightlife is Oceana, on the right, one of the foremost clubbing experiences in the country. Originally a cinema, the building opened as the Plaza on 8 July 1929 with its first 'talkie', the smash hit 'The Singing Fool' with Al Jolson. However, in July 1936 the Odeon circuit acquired the picture house, surviving until its eventual closure in 1963. The Odeon is seen here in this late 1940s postcard, dated by the latest feature film being screened, *A Woman Destroyed* starring Susan Hayward.

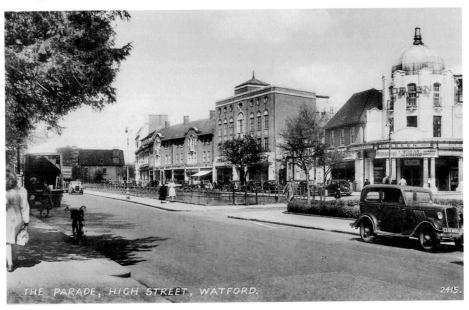

THE PARADE, HIGH STREET, WATFORD. 2415.